DI060863

VICTORIAN JEWELLERY

VICTORIAN JEWELLERY

Deirdre O'Day

Charles Letts Books Limited

The author is particularly indebted to Mrs. Shirley Bury who was unfailingly generous with her knowledge of the period and of the subject, and whose comments while reading the manuscript were invaluable; to Mr. Claude Blair for his assistance and encouragement; and to Mr. A. Jobbins for kindly advising her on matters of gemmology. She would also like to thank Mr. Ronald Lightbrown, Niamh Whitfield, Mrs. Elaine Barr, Mr. Michael Snodin, Mr. Charles Truman, Mr. Anthony North, Françoise Bechet de Balan, Mrs. Elizabeth Bonython, Mrs. Caroline Richards, Mr. Paul Forrester, Miss Rosalind Christie, Mr. M. W. Bell, Mr. Anthony Gardner, Mr. Michel Becker; and the Victoria & Albert Museum, and the various owners and private collectors who permitted her to illustrate items of jewellery from their collections.

For this edition the author is grateful for the kind assistance of Mrs. Shirley Bury and Mr. Geoffrey Munn.

First published 1974
Revised edition 1982
by Charles Letts Books Limited
77 Borough Road, London SE1 1DW

Photographs: Michael Dyer Associates
Cover photography: A. C. Cooper Ltd.

ISBN 0 85097 359 7

Printed and bound by Charles Letts (Scotland) Ltd

CONTENTS

INTRODUCTION

In 1837 the eighteen-year-old Princess Alexandrina Victoria became Queen of England: in 1901 she died. The sixty-four years of her reign had seen a period of extensive experimentation and development during which the industrial changes of the late-18th century had come to fruition, the wealth of European governments had been augmented by the expansion of their colonial powers, and an enlarged middle class was richer and more powerful than ever. The excitement felt by the early Victorians who had inherited the fruits of the Industrial Revolution can well be imagined. Faced with the challenge of harnessing their ideas to the machine and aided by the economic resources at their disposal, they responded with the same self-confidence, energy, and drive for self-improvement which informed most Victorian endeavour. In the sphere of the decorative arts this sense of challenge combined with other factors to produce the complex chain of action and reaction which resulted in a plethora of styles and objects with which the materialistic Victorians could decorate their houses and their persons. Though her personal contribution to all of this was relatively slight, Queen Victoria's name has come to symbolize the particular qualities of the age.

The prime function of jewellery is to enhance and decorate the human form, but it cannot be divorced from the decorative arts, nor, indeed, by its nature, from the prevailing social and economic trends of its time. In respect of techniques employed in its manufacture, jewellery is allied to the crafts of the goldsmith and enameller and, occasionally, also to the arts of the miniaturist or sculptor. Renaissance jewellery often encapsulates contemporary architecture and sculpture: Victorian jewellery did this and more.

In attempting to clarify the subject of Victorian jewellery within the limited space of this book, I have arranged the colour plates with their accompanying texts chronologically, so as to trace the overall development which took place. While it has been possible to single out the major movements and influences, it has been necessary, in some instances, to use a particular piece or group as an archetype from which a series of departures were made, for it is impossible to record everything visually. However, the special difficulty which attends any discussion of this subject is the fact that at no time is it possible to consider one style as being definitive of its time. In this respect it differs from a study of the costume of the period, for, though at times both were closely related, fashions in clothes changed fairly rapidly and distinctively

– so that, in some cases, it is possible to date them almost to the year – while styles in jewellery, in common with other articles of intrinsic value such as silver, tended to change more slowly and to overlap from one stage to the next. But the significant difference is caused by the plurality of styles and the mass of conflicting ideologies which affected the decorative arts.

Major innovatory art movements co-existed both with revivals of earlier styles and certain ever-present popular themes. An intense romanticism, symbolized by the romances of Sir Walter Scott, stimulated the Gothic visions of A. W. N. Pugin and other members of the Victorian medieval movement, but it also influenced the thinking of Sir Henry Cole and others responsible for the education of designers for industry. Cole, as superintendent of the Science and Art Department, was not only in charge of the government-aided art schools in the United Kingdom from 1852, he was also the first director of the museum now known as the Victoria and Albert. He was pledged to 'the improvement of public taste in design' and to fostering the needs of industry – for mechanized mass-production was hailed as one of the great achievements of the age. Yet he could not resist the charms of craftsmanship, as is shown by his acquisitions for the museum. They are worlds removed from the shoddily designed and produced goods that some at least were prepared to accept as the price of industrial progress.

Travel and communications generally were vastly improved by the proliferation of railway links in the twenties and thirties, and by the later introduction of steam-powered boats. Europeans, finding themselves, in consequence, less isolated, were able to cultivate an interest in foreign countries and cultures, an experience formerly confined to the aristocrat and the scholar. By 1856 it was possible to embark upon an organised tour of the Continent arranged by Thomas Cook, and the opportunity of doing so was seized enthusiastically by many Victorians, whose diaries of their journeys are full of rapturous accounts of the glories they encountered. The growth of tourism greatly boosted the trade in jewellery indigenous to the countries visited, for example, mosaics, *pietra dura*, coral, and cameos from Italy, carved ivory from Southern Germany and Switzerland, and silver-mounted 'cairngorms' from Scotland.

For those who remained at home the new phenomenon of regular international exhibitions of commerce and the arts, with many of which Cole was concerned, brought the ideas and technical advances of participating countries into competitive view for the first time. Inevitably also, there was much inter-national commerce, and the prosperous British jewellery trade was prepared to employ skilled foreign craftsmen, as well as to import a great deal of raw materials.

With the wider distribution of wealth, the ownership of jewellery ceased to be vested in the rich or the aristocratic. The services of the *bijoutier* were now required by a wider group of people who avidly collected whatever fashion dictated. The successful Victorian businessman who had 'arrived' could advertise the fact by the quantity of glittering jewellery with which he endowed his wife. Depending upon the degree of his wealth and taste, she might indulge herself in original pieces designed and made by the best craftsmen, or invest in one of the better mass-produced versions of a commercial jeweller. Increasing mechanization also enabled manufacturers, in Birmingham and elsewhere, to turn out cheaper versions of the same pieces for those of more slender means. By the seventies, when mass-production was intensified and there was a ready supply of cheap silver, the mistress of the house might, in turn, be emulated by her servants who could perhaps afford to buy a die-stamped silver locket, pendant, or brooch, the style of which related to her own splendid jewellery.

Romanticism

The world into which the early Victorians were born was heady with romanticism. The Romantic Movement, with its roots in the late-18th century, was to be the unifying factor in an age which was still coming to terms with the effects of the Industrial Revolution. From the heights of idealism to the depths of sentimentality, romantic attitudes and behaviour were manifest in every aspect of Victorian life. Perhaps because of the harshness and feeling of dehumanization which inevitably accompanied industrialization, the Victorians turned for reassurance and a sense of continuity to the past; and by imitation tried to recapture its most colourful and humanizing qualities. They looked to the precepts which had first been outlined by Jean-Jacques Rousseau in the 18th century and refreshed themselves by contemplating the order and simple beauty of the natural world. The creative artists of the Romantic Movement – poets, painters, composers and writers – based much of their work on medieval romances, on heroic myths and exotic tales, and on idealized concepts of love and valour, and they explored the possibilities of expressing ideas and emotions by means of natural imagery.

The early part of the period with which we are dealing was dominated, in England and France, by a positive passion for the Middle Ages. The craze for medieval costume balls and for events like the Eglinton Tournament of 1839 – in which some of the participants wore genuine antique armour – had started in France as early as 1829. In that year the Duchesse de Berry, daughter-in-law of Charles X, held a costume ball, the *Quadrille de Marie Stuart*. English medievalism, the child of Georgian 'Gothick' was reinterpreted both by Pugin and his fellow architects, and by

9

artists. The Pre-Raphaelite Brotherhood, started in 1848, was powered by medievalism and, in attenuated form, it persisted in the Arts & Crafts Movement.

Medievalism was at its peak in Victoria's early years as queen, and jewellery, costume, and hairstyles in England and France reflected a fashion which ranged for inspiration through the Middle Ages to the Renaissance and beyond.

A less marked, but nonetheless significant, inclination for jewellery which nostalgically recalled the grace and glamour of the 18th-century rococo style was current at the same time (see Plate 7). In France this style continued into the Second Empire, due to the efforts of Napoleon III's wife, the Empress Eugénie, to recreate the court life of pre-revolutionary France. At the time of their marriage in 1853, the Emperor had managed to retrieve many of the French Crown Jewels which had been stolen in 1791. The jewels were re-set for Eugénie and were incorporated into her own already magnificent collection, thus representing a tangible link with the past. Eugénie, a woman of natural beauty and taste, was recognized as a leader of fashion and her jewellery became the model for a great deal of the formal jewellery thereafter.

A strong vein of nostalgia in 19th-century Romanticism was matched by an acute interest in the natural world. The natural sciences of geology, botany, and zoology were studied by both women and men, and specimens were zealously collected for their aesthetic and academic interest. Geological finds of all kinds were given prominence by being fashioned into objects; and jet, fossils, tortoise-shell, malachite, lapis lazuli, agates, and other geological matter joined the precious stones on the jeweller's bench.

The steady development of Naturalism in the decorative arts during the second quarter of the century is strongly represented in jewellery. It is first discernible as the inclusion of natural motifs, such as leaves or flowers, in a general decorative scheme; or by a conventionalized treatment of natural subjects (see Plate 9). Gradually the emphasis shifts towards an increasing realism and subjectivity, reaching its apogée in the late-forties, with a fully three-dimensional treatment coupled with appropriate texturing and colour. (See Plate 27.)

Antiquarianism and archaeological jewellery

Around the mid-century, Romanticism in England was paralleled by another movement which began to gather strength in the thirties and which became the voice of the government establishment. Accepting the need to seek inspiration from the past or to borrow from other cultures, supporters of this movement insisted that historical reconstruction must be based on disciplined research and antiquarian knowledge, including the scientific application of archaeological evidence. They argued that

authenticity or 'purity' of style was a moral obligation. It was the view both of the establishment and of those who espoused antiquarianism that contemporary taste was poor, and design feeble and ill-conceived. Standards of workmanship had sunk to mediocrity and worse, lagging far behind most other countries, particularly France, whose attainments in this area remained unchallenged.

The answer was to be found in education. When, for example, Henry Cole took up his appointment in 1852, so strong were his convictions that he purchased, for his new museum, a group of objects for the express purpose of using them to demonstrate 'False Principles of Design'.

As far as jewellery was concerned the use of the archaeological approach, exemplified by various historical styles, was crucial to the radical change which took place in its appearance from the fifties to the eighties. To a limited extent, archaeology had already affected jewellery design in the 19th century – as in the case of the Empire style – and Irish reproductions of Celtic jewellery, together with work based on Assyrian sculptures discovered by Sir Austen Henry Layard at Nineveh, were shown at the Great Exhibition in 1851. But the enormous success of the neo-Etruscan style, which was to dominate fashion for many years and whose influence can still be seen in the early years of the 20th century, was largely due to the work of the Castellani family of Rome. Their reproductions of Byzantine, Medieval, Greek, Etruscan, and Roman jewellery were praised by public and trade alike, when they were shown in England at the International Exhibition in 1862, and started a trend which was adopted by English and French jewellers. The Castellanis claimed to have discovered the techniques employed by the Etruscans and to be reproducing exactly from classical prototypes. Largely reliant upon the techniques of the goldsmith – there was relatively little gem-setting, and enamelling was subsidiary – a high standard of execution was essential and the attainments of the few expert craftsmen who handled the first wave of archaeological jewellery in England did much to redeem the image of the British craftsman.

Commercialism, the 'Aesthetic' reaction and late-Victorian jewellery

The stylistic clarity of archaeological jewellery was, however, short-lived, and was soon obliterated by the eclecticism of high Victorian design. A gradual departure from pure reproduction was made by the Castellanis themselves, who were as capable of inventing in a mode as were their imitators, such as Giuliano and Robert Phillips in England, and Fontenay in France. Taste in the sixties and seventies favoured the wearing of a lot of large and heavy jewellery, preferably made of gold, and the 'Archaeological' style, pure or modified, was much in demand.

Once jewellery was released from the hot-house of antiquarianism into the hands of commercial manufacturers, there was a progressive breaking down of generic distinctions; and anomalies such as an 'Egyptian' necklace rendered in large diamonds or pieces made with a combination of Gothic, rococo, and classical motifs either went unnoticed or were considered perfectly acceptable. As time went on, commercial firms, whether small workshops in London or Paris, or factories in Birmingham, selected, modified, and adapted, with a bewildering disregard of context, from the wealth of thematic material inherited from the previous generation. In the increasingly debased pastiches which poured out as the century moved through its last quarter, one can find a distorted summary of all that had gone before.

Artistic circles deplored the spread of mechanically-made jewellery, and vilified fashionable jewellery for its soullessness and vulgarity. The women connected with the Pre-Raphaelite Brotherhood eschewed fashion and chose to wear antique and oriental jewellery. Trade was again being carried on between Japan and the outside world and the appearance of examples of Japanese art, including jewellery, stimulated a rebirth in the decorative arts. This was the 'Aesthetic' period, and commercial manufacturers joined in the rush to imitate Japanese work. (See Plate 43).

The last quarter of the century brought about a revolution in taste and thought. Established traditions were rejected, especially those dominating the previous generation, and the way opened for the 'Modern Movement'. Women of the eighties and nineties were more independent, active, and political and were prepared to expend energy on furthering their aims. Their repudiation of the sumptuousness of high Victorian taste in jewellery caused a temporary crisis in the trade, for, by the late eighties, so little jewellery was being worn during the day that the Birmingham Jewellers' Association was driven to calling upon Alexandra, Princess of Wales, to exert her powerful fashion influence by wearing more. They need not have worried, for, in the nineties, the passion returned with a taste for very small delicate pieces some of which reflected the revolutionary movements of the *fin de siècle*. Interest had moved from settings – which were minimal – to stones, and preferably those which lacked colour. The evening jewellery of the rich was still resplendent with diamonds, which were now mainly obtained from the mines of South Africa, where the first finds had been made in about 1867. The eclectic revivals were still available for those who wished to wear them, but even these were diminished in size, and there was a mass of small novelty jewellery. (See Plate 48.)

The Arts & Crafts Movement

First Pugin and then, from 1849, John Ruskin had lent their eloquence to protest at the damage done to man and art by the Industrial Revolution. In Ruskin's view, art was inseparable from the society in which it was created, and he outlined radical ideas for social reform and the betterment of man through art. He disapproved of the copying which was the incipient disease of 19th-century industrial art and asserted the right of the individual to dignity of labour in a machine age of increasing standardization. Like William Morris, who, a generation later, was fired by Ruskin's ideas into action, his ideal was represented by the medieval designer-craftsmen, working in small cooperative associations and preserving the sanctity of craftsmanship. These ideas finally coalesced, in the eighties, with the foundation of the Arts & Crafts Exhibition Society, with which Morris was concerned, and the establishment of such groups as C. R. Ashbee's Guild and School of Handicraft in 1888. The Movement, however, had its commercial adherents and some of the craftsmen found it impossible to remain independent of commercial firms, for whom they designed, sometimes anonymously.

The Arts & Crafts Movement opened the way to much individual work which brought a new look to jewellery – simplicity, directness, and a deliberately unfinished quality. Yet the influence of earlier historical styles, such as the Celtic revival and Pre-Raphaelitism, were clearly recognizable.

Certain designs, particularly those of Ashbee, were taken up by commercial firms and the influence of the movement spread, through the exhibitions arranged by the Art & Crafts Exhibition Society in the nineties.

Art Nouveau

'L'Art Nouveau', the name chosen by Samuel Bing for his shop in Paris in 1895, came to be used by more conservative critics as a disparaging label for the radical style which invaded the decorative arts in Europe and the USA from the mid-nineties until about 1910. Perhaps because of its lack of constraint, its sensual and attenuated forms, and its frequently erotic overtones, Art Nouveau was dismissed as decadent.

For jewellery it proved to be a fertile ground and architects, sculptors, silversmiths, and designers, such as Henri van de Velde in Belgium, Georg Jensen in Denmark, Joseph Hoffmann in Vienna, and Louis Comfort Tiffany in New York, were drawn to work in the medium under the influence of the new style.

Within the movement there were clear national distinctions. The desire to break with tradition and to experiment with form was expressed in different ways. Where, for example, in France forms were likely to be sinuous, in Germany they were angular, and in Scandinavia fleshier and more stolid. All versions of the

style were affected by 19th-century Naturalism and the art of Japan.

The creation of original pieces of work – and it is in these that one sees the success of Art Nouveau jewellery – was limited to a small number of craftsmen in each country. In France the traditional mastery of goldsmithing techniques combined with striking originality of treatment to bring the *bijoutiers* to the fore once again, and the work of men like Fouquet, Gaillard, Vever, Gautrait, and particularly René Lalique, was often more in the realm of sculpture than of jewellery. Their work was also notable for innovatory techniques and materials, and the juxtaposition of these was an important part of the composition.

The predilection for *Plique à Jour* enamelling, and for glass which Lalique introduced to jewellery at this time, meant, unfortunately, that much of this jewellery was impractical to wear. Nevertheless, the *bijoutiers* found ready customers in the dashing Parisian women of the *Belle Epoque*. Though some pieces were produced in series, the complexity of techniques and materials did not lend itself to mass-production.

In the United Kingdom, the work most sympathetic to Continental developments was produced in Scotland by Charles Rennie Mackintosh and his followers. In England Art Nouveau was the characteristic mode of *Liberty & Co*, and of other commercial firms. Though not accepted by the Arts & Crafts Movement, its influence is, even so, discernible in their work.

Cameos, which since their classical beginnings had had one other great revival during the Renaissance, were tremendously popular for most of the 19th century. The fashion for cameo jewellery, emerging as a result of 18th-century neo-classicism, appears to have been fostered at the court of the Emperor Napoleon whose wife Josephine greatly favoured them. Napoleon's gift to her of a parure consisting of eighty-two antique cameos surrounded by pearls, set the fashion for the extravagant use of cameos – preferably antique – as the *Journal des Dames* of 1805 indicates: 'A fashionable lady wears cameos at her girdle, cameos in her necklace, cameos on each of her bracelets, a cameo on her tiara. Antique stones are more fashionable than ever, but in default of them one may employ engraved stones.'

This, however, does not typify the fashion as it affected most women in Europe during the 19th century. For them a brooch, a pair of earrings, or, perhaps, a necklace set with cameos, was sufficient.

The ubiquitous cameo brooch was worn in various ways; one of the prettier fashions being to attach it to a velvet ribbon encircling the throat; a more practical one being its frequent use as a shawl clasp. Quality ranged from expertly carved examples in precious and semi-precious stones to the many cheaper imitations in shell, glass, and other substitutes which proliferated as the century progressed and which were of variable quality. The subject matter was generally 'classical' but a number of cameos echoed the mid-Victorian preoccupation with the Renaissance and after, by depicting various courtly ladies of the 16th and 17th centuries in the elaborate dress of the time.

Elizabeth I and Mary Queen of Scots were particular favourites but Marie de Médicis (died 1642) appears on a signed cameo now in the Victoria and Albert Museum (165–1900). Of onyx, it is set in a pendant made by Castellani. On rare occasions genuine classical and renaissance cameos were mounted in what at first glance appears to be an original setting, but is, in fact, the work of a skilful 19th-century craftsman reproducing earlier styles and techniques with startling exactitude: a practice which has caused some confusion.

A purely Victorian invention was the cameo *habillé*, which appeared some time in the 1860s, in which the subject of the cameo is herself adorned with jewellery (see ivory cameo, Plate 10).

There was a considerable production of shell cameos in Italy, France, and England. The different-coloured strata of the shells were utilized in much the same way as the contrasting bands of the agate and onyx stone seen here. Coral, ivory, and the pleasantly coloured lava at Pompei were all carved *en cameo*. The latter, in muddy greens and browns, made surprisingly attractive jewellery.

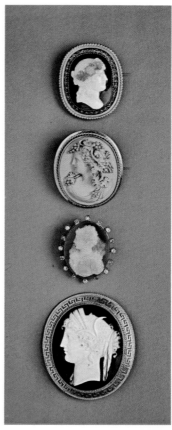

Cameo Corner

Plate 1

1 Brooch. Agate cameo of a Bacchante in a diamond-set gold mount, the different-coloured strata of the stone exposed to provide depth and contrast. Possibly FRENCH: 1820s–1830s

2 Brooch. Lava carved in imitation of a cameo and mounted in gold; a Bacchante. ITALIAN: 1840–1860

3 Brooch. Sardonyx cameo of Elizabeth I or Mary Stuart, in a diamond-set gold mount. Probably ENGLISH OR FRENCH: 1860s–1880s

4 Brooch. Onyx cameo of Demeter (or Ceres) in a gold mount. FRENCH OT ITALIAN: 1840s–1860s

15

Plate 2

Earrings. Shell cameos depicting a nymph and an amorini and, at the top, the heads of a satyr and a bacchant; in a thin gold setting which has been stamped out in the revived rococo style.
FRENCH: 1830s–1840s (cf Vever Vol. I, page 152, see Bibliography)

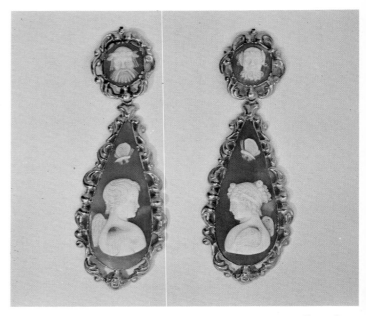

Cameo Corner

These earrings were made at a time when cameos were still extremely fashionable. Proof that, in the 1870s, their popularity was declining in the face of opposition from cheap machine-made jewellery, however, is afforded by the following comment which appeared in a contemporary periodical, *The Paris Exhibition of 1878, An Illustrated Weekly Review* (March 1879). The writer indicates an alternative outlet for the active shell-carving industry: 'a development of the deeply interesting art of cameo-cutting in the direction of general instead of personal ornament was determined upon by Messrs. Francati and Santamaria, the well-known cameo-makers, of 65 Hatton Garden ... Observing ... a certain decline in the ordinary cameo industry consequent upon the fierce competition of other ornament; observing also that the popular taste for artistic ornament was rising in an obverse ratio, they determined to apply cameo work to large ornaments, and instead of cutting up a shell into innumerable brooches, pin tops, earrings etc., to engrave the shell all over with the most artistic designs, in order to render it suitable for the decoration of a chimney-piece or the ornamentation of a cabinet ... They remind one to some extent of Wedgwood ware, the designs being fanciful and beautiful ... Some shells have only a well-known head, or a simple figure in an oval engraved upon them, the rest being either left in the rough or covered with the usual floral or architectural decoration ... Messrs. Francati and Santamaria ... have really raised cameo work from the industrial region of jewellery to the artistic realms of general ornament. Comparison is as between a very fine brooch or pin and a handsome statue.'

Plate 3

Bracelet. Gold; in the form of a
serpent, the head decorated with
pavé-set torquoises; the eyes of garnets.
From its mouth hangs a heart-shaped
locket.
Probably ENGLISH: 1830s

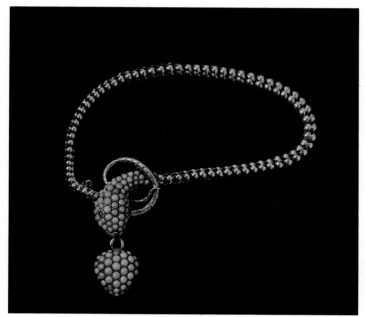

Shrubsole

The serpent motif, which could be associated both with the
natural world and with antiquity, was prominent in jewellery of
the romantic early period and continued in various guises
throughout the century to be reinterpreted at its end, appearing
again amongst the sinuous forms of Art Nouveau. Notably
in the hands of René Lalique whose compellingly sinister corsage
ornament of 1900 consisted of nine writhing serpents. (The
Gulbenkian Foundation Museum, Lisbon).

Serpent bracelets of the Romantic period concentrated lavishly
on the head. This could be a gold-mounted cabochon garnet or
amethyst; or of gold – enamelled, engraved, encrusted with gems
or pearls, or decorated with the popular *pavé*-set torquoises which
sometimes continued down the articulated body forming 'scales'.
Another type of serpent bracelet was of enamelled gold and
encircled the arm several times – in the late 1870s plain gold
serpents coiled sometimes as many as nine times around the long-
gloved arms of the time. Serpent jewellery was also made in jet
and ivory.

Plate 4

Necklace, Brooch and Earrings:
Opaque glass mosaic plaques set in
goldstone with open-backed gold
mounts linked by gold chains.
ITALIAN: *c.* 1830–1840

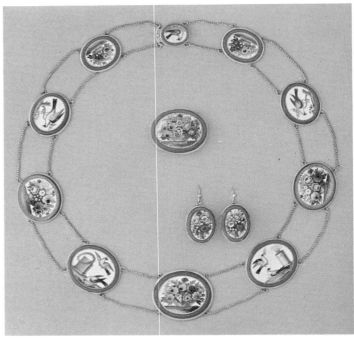

Cameo Corner

The artistic achievements of the classical past, which had had such
a profound effect upon European art in the second half of the 18th
century, following upon the discoveries at Pompei and
Herculaneum, had created a fervent interest in antiquity which
was carried over into the 19th century. Amongst the souvenirs
which exploited this interest, the tourist in Italy could buy
jewellery composed of mosaic plaques which featured classical
ruins and bird studies derived from Pompeian wall paintings.
Originating in Rome and Naples, production spread to most of
the tourist centres of Italy. Export of the plaques to England is
recorded as early as 1807 where, as in France and Switzerland,
they were mounted as jewellery or set into the lids of gold snuff
boxes and *nécessaires*. The style of this necklace, with its units
linked by fine gold chains, is in keeping with the 1820s but the
addition of the alternating floral studies would place it nearer to
the middle of the century when Naturalism was in the ascendant.
A commentator in the mid-1860s remarked that, in England at
least, mosaic work had gone out of fashion but in Italy the
industry continued unabated.

Plate 5

1, 2 Two Brooches. Opaque glass mosaic brooches depicting classical ruins; set in black glass plaques in silver-gilt settings.
ITALIAN: The plaques 19th century; the silver-gilt settings modern English.

3 Pendant. *Pietra Dura*.
ITALIAN: mid-19th century

4 Brooch. Opaque glass mosaic brooch set in black glass plaque within a gold frame.
ITALIAN: mid-19th century

5 Brooch. *Piétra Dura*; in a gold frame.
FRENCH: (Paris) The frame bears the Restricted Warranty gold mark for Paris 1838–1847

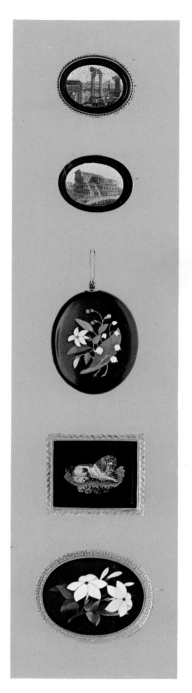

From its originally classical connotations, the subject matter of mosaic jewellery was later extended to include such homely themes as this faithful mid-Victorian dog (4).
A related technique was *Pietra Dura* (Italian 'hard-stone') a form of decorative inlay work for table tops and furniture panels using marbles and other coloured hard-stones, in an *œuvre* which has continued more or less without interruption in Florence since the late-16th century. The small panels used for jewellery in the 19th century were mainly restricted to floral designs but were of a sufficiently high standard of execution to be included in jewellery made by such master craftsmen as Castellani. Like the mosaics, these Pietra Dura panels were exported and mounted in other countries and were also used for gold boxes. An English version of the work was produced in workshops set up by the Duke of Devonshire, owner of the Derbyshire fluorspar mines, early in the 19th century.

Cameo Corner

19

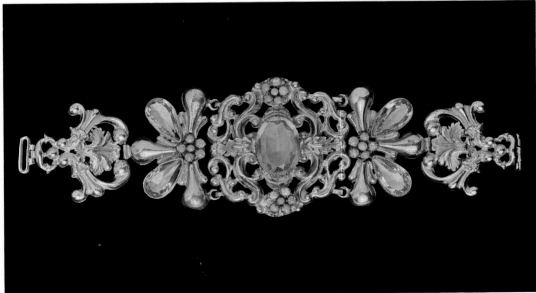

Plate 6

Neckband. Stamped pinchbeck set
with turquoise and citrine pastes.
ENGLISH: 1830–1840

Pinchbeck, usually an alloy of copper and zinc which simulated
gold, was the invention of the watchmaker Christopher
Pinchbeck (1670–1732) and was used for making cheaper
jewellery set with pastes or inexpensive stones during the first half
of the 19th century. A similar alloy was also produced in France.
However with the lowering of the carat standard of gold in
England in 1854 the former usefulness of pinchbeck was
diminished and the advent of electro-gilded base metals brought
about its eventual demise. This pinchbeck neckband is looped at
either end to take the velvet ribbon with which it would have
been attached to the neck. The fashion for jewellery of this type
was revived in the 1890s with the 'dog-collar' – a wide band
consisting of several rows of pearls or diamonds. Dog-collars
were popularized in England by Alexandra, Princess of Wales,
Queen Victoria's daughter-in-law, for whom they served the
cosmetic function of concealing a neck scar.

Plate 7

Brooch with pendant: Aquamarines in a setting of stamped gold scrollwork; the pendant section suspended on a gold chain.
FRENCH or ENGLISH: 1840s

Earrings. Foiled amethysts in settings of gold scrollwork. In a box marked: Lunardi-Bijoutier-Joaillier, 15 Place Dauphine.
FRENCH: 1830s

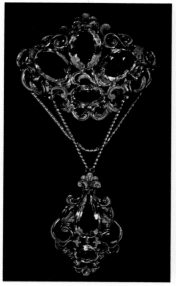

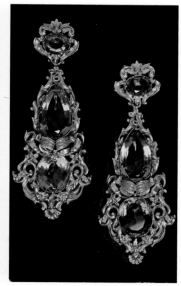

Harvey & Gore *Cameo Corner*

The ostentatious French jewellery of the era of Louis Philippe (1830–1848) and its English counterpart, in common with the spirit of the previous sixteen years since the restoration of the monarchy in France, represented a strong backward-looking trend to the court styles of the 18th century and particularly to the rococo. In spite of intellectual resistance and strong opposition from the increasingly important archaeological styles, it was still very much in evidence in the middle of the century. Large coloured stones (or pastes over coloured foils) in settings of rich gold scrollwork; the frequent use of the traditional *girandole* and *cartouche* in its design; and the reappearance of the parure and the *sévigné* brooch, distinguished jewellery of this type. The scrollwork settings – a mixture of swirling leaves and tendrils, flowers and *rocaille* – gave an illusion of depth and weight whilst being stamped out of thin sheets of gold. Naturalistic highlights were sometimes added by means of enamels, chasing, and blooming (see Plate 18). The brooch with pendant occurred in the French restoration period (see Vever Vol. I facing page 128) but the fine looped chains were an addition of the late 1840s and 1850s and may be connected with the then current vogue for Moorish jewellery. (See Plate 29).

Plate 8

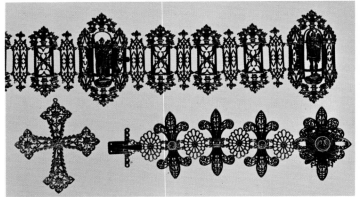

Cameo Corner

(Above) Pair of Bracelets (linked for the photograph). Cast iron: linked units of Gothic tracery; the clasps are larger units containing standing figures of St. George (or St. Michael?) and Peace (?).
Marks: 'Dev' (cursive) on each unit and twice on the clasps. Probably an abbreviation of the cursive signature of Devaranne of Berlin—with which it corresponds.
GERMAN: 1830–1840

Bracelet. Stamped sheet-iron units of alternating fleur-de-lis and openwork motifs. Small reliefs mounted on polished steel discs are applied to the fleur-de-lis (one missing). They are respectively: a cross flanked by an anchor and a flaming heart; a rose; and a classical head in profile.
FRENCH (?): 1830–1840

Cross: Cast Iron.
GERMAN: *c.* 1830

An interesting side development is illustrated by the case of Berlin Iron jewellery, which emerged as a by-product from the Berlin Iron foundry some time after 1804 and came into its own during the War of Liberation against Napoleon in 1813–1815. Patriots who donated their gold jewellery to the war effort at that time received in exchange cast iron jewellery bearing the proud inscription: *'Gold gab ich für Eisen'* (I gave gold for iron). Such jewellery soon became fashionable in its own right and was produced in great quantity, exported, and even shown at the Great Exhibition in 1851 – though by that time it had passed its peak both of production and of favour.

Although for the major part of its existence it was firmly established in the neo-classical idiom – with necklaces composed of openwork medallions of classical subjects, pseudo-cameos mounted on polished steel plates, and fine mesh chains – this gave way in the 1830s to a splendidly appropriate gothicism. There appear to have been three principal techniques: fine casting from moulds (the top bracelets and the cross are of this type); stamping out of sheet metal (the fleur-de-lis bracelet), a flimsier result; and a fine filigree, which has been attributed to the Prussian province of Silesia where this type of work is believed to have been carried out in the 18th century; bags, purses, card cases etc. as well as jewellery were made by this means. Iron jewellery was also made in France, appearing late in the 1820s, apparently as mourning jewellery. Several makers were working in Paris, including M. Dumas (see Vever Vol. I page 344). As yet, however, the well-known marks remain German ones: Geiss of Berlin; Schott of Ilsenberg-am-Harts; Lehmann of Berlin; and Devaranne of Berlin (the latter perhaps a Frenchman, Belgian, or Swiss working in Germany). Both Schott and Devaranne exhibited jewellery at the Great Exhibition. Perhaps the result of a redeployment of labour in iron foundries due to the decreasing demand for armour, Berlin Iron jewellery in its 'Gothic' phase provides the collector with the now rare opportunity to acquire pieces in Gothic Revival style.

Plate 9

Necklace, Earrings and Brooch.
Chased gold and seed pearls in the
form of bunches of grapes and vine
leaves. (The brooch was probably once
part of a hair ornament.)
ENGLISH or FRENCH: *c.* 1840

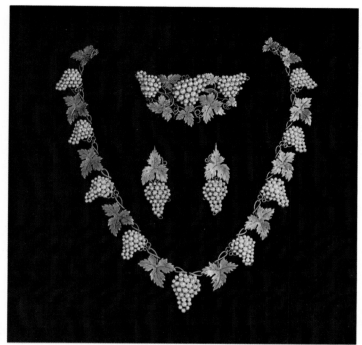

Cameo Corner

The elegant combination of gold and seed pearls to represent
grapes on the vine has occurred periodically throughout the
history of European jewellery since classical times, and in the
second quarter of the 19th century, with the renewed interest in
natural forms, it emerged again. The stylized and still largely
two-dimensional treatment of the motif in this parure plus the
even distribution of its elements, places it around 1820–30,
though the motif continued on into the mid-century when it was
given a more plastic and realistic interpretation as thick bunches
of carved dark amethyst grapes hanging heavily from leaves of
green-enamelled gold (see a necklace and earrings in the Victoria
and Albert Museum M135-b-1951).
This was also the period of the seed pearl parure, when complete
sets of jewellery were made from hundreds of these minute pearls
strung precariously together on horsehair in floral and leafy
patterns. Not surprisingly, few of these vulnerable pieces have
survived intact.

Plate 10

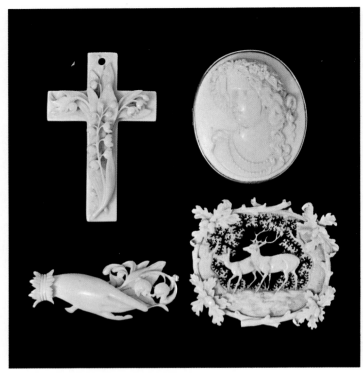

The Purple Shop

In the midst of the cross-currents of styles and manners, transient
vogues and occasionally radical departures which constituted the
Victorian jewellery scene, so-called 'popular' jewellery remained
fairly static. Certain forms, mainly sentimental and symbolic,
which were products of the romantic climate of the early years,
persisted, by dint of their enormous appeal, and were virtually
unaffected by the activities in the mainstream of design. Jewellery
made from ivory, coral, jet and tortoise-shell comes into this
category and tends to share a common repertory of motifs, some
of which are shown here. Most of the ivory jewellery was
produced in Dieppe, the industry there having been revived in the
early 1800s by the Duchesse de Berry, but also in Switzerland and
Germany. Around 1850, a less expensive means of producing
ivory-coloured jewellery was attempted by moulding Parian
porcelain (best known for its use in reproducing sculpture) in
imitation of carved ivory, but because of its fragility Parian
proved to be impractical for jewellery. Similarly, for a short time
the creamy porcelain from Belleek in Northern Ireland was used
to make brooches.

Plate 11

Brooch. Silver in the form of a fully
modelled hand with cuff.
Marks: H & T (unidentified),
[Design] Regd. 30th March 1848.
ENGLISH: 1848

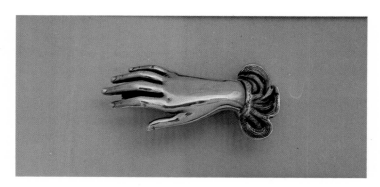

Sothebys, Belgravia

Of the symbolic motifs mentioned on the opposite page, the hand
– clenched, extended, or holding a flower – is perhaps the most
interesting. Its precise significance, if indeed it had just one,
remains unclear but one can speculate upon some of the reasons
for its presence in early Victorian jewellery. Clasped hands as a
love symbol date from classical Roman rings and reappeared with
the medieval Fede rings (from the Italian: *mani in fede*, literally
'hands in faith') which continued into the 18th century. With this
in mind it is possible to interpret the single hand brooches of the
Romantic, early-Victorian period as symbolizing an offer of love,
friendship or peace. A second and more bizarre influence comes
from Italy via tourist souvenirs; in this case the talismanic hands,
little coral charms which for centuries had been worn as a
protection against the evil eye and to ensure fertility. Finally,
Victorian Naturalism involved the close study of all aspects of
natural life and phenomena. The isolation of a single part of the
human body, the better to examine and appreciate its intrinsic
beauty, is part of this. Hand sculptures occurred during the first
half of the century and it is perhaps from these that this sculptural
silver brooch derives.

Apart from its use for brooches, which appeared in every kind
of material including Berlin Iron work (see Plate 8), the motif was
also used functionally as a purse clasp, to suspend a watch from a
chain, or as the links of a chain. Vever (Vol. I page 249) shows a
watch or muff chain which is entirely composed of hands
clenched around connecting rings – a treatment of the motif
which, incidentally, occurred in the early-17th century.

Plate 12

Brooch. Chased silver and Scottish agates; in the form of a dagger.

SCOTTISH: *c.* 1840–1860

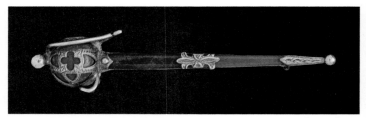

Cameo Corner

Grouse claws set in silver to make brooches; miniature dirks of silver-mounted local agates (popularly known as 'Scotch Pebbles'); Highland shoulder brooches set with the brown and yellow tinted quartz which was called cairngorm: these are some examples of a whole range of jewellery which was designed to evoke Scotland and her romantic past. The great popularity of such designs in England was symptomatic of the widespread English passion for things Scottish; a passion to some extent sustained by Queen Victoria's choice of Balmoral Castle as a summer retreat and her obvious fondness for Scotland and its customs.

In 1878 – according to the following excerpt from the periodical *The Paris Exhibition of 1878, An Illustrated Weekly Review* – the dashing Scottish image appears still to be very much in favour: 'Is it possible to find anywhere . . . a prouder or more gorgeous spectacle than that of a Highland piper in full national costume, kilt, sporran, philibeg, skeke-dhu, and all the rest of it, as – with the great chanter giving forth its most sonorous pibroch – he marches to and fro on the terrace before his chief's residence? . . . The effect of the waving outlines and rich colours of the clan-tartan is enhanced by a multitude of engraved silver buttons, shoulder brooches, embossed buckles, jewelled dirks etc. until, in a full and archaeologically correct Highland costume – there is a perfectly dazzling combination of silver – burnished, dead and frosted – combined with precious stones'.

The effect of this vogue had already been felt in France where, in 1860 for example, bracelets enamelled in imitation of tartan ribbon were being worn to match the currently fashionable *robes écossaises*. Brooches of Celtic design also appear there. As with Irish jewellery, archaeological finds – like the 8th-century Hunterston brooch – inspired contemporary pieces. Both the original and the mid-19th-century version of this brooch are in the National Museum of Antiquities of Scotland in Edinburgh. Other designs were based on various elements in Celtic ornament

During the 1860s in Edinburgh the production of silver and scotch pebble jewellery developed into a major industry which was later taken up by the Birmingham manufacturers who have continued production to this day.

Plate 13

Brooch. A reduced electrotype copy or a cast reproduction of an Irish 8th-9th century brooch which was found in Co. Cavan (Southern Ireland). The original is in the National Museum of Ireland, Dublin.
Marks: West & Son, College Green, Dublin. FEC(I)T.
[Design] Registered December 17th 1849.
IRISH: 1849

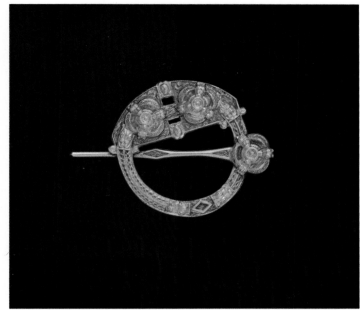

N. Bloom & Son

Irish archaeological discoveries of the 19th century included some richly decorated Celtic brooches and fibulae of remarkable beauty and superb workmanship. Their romantic appeal to an age which venerated the achievements of earlier cultures was soon being exploited by Irish jewellery firms, who perceived the commercial advantages of reproducing ancient ornaments of a distinctly national character which could be adapted for use with modern dress. Many of the new designs were registered at the Patent Office and examples of the reproduction jewellery were shown at the big exhibitions. The Cavan brooch (known at the time as 'the Queen's brooch', Queen Victoria having been presented with a copy) was shown by West & Son of Dublin at the Great Exhibition of 1851 and was illustrated in the *Art Journal* catalogue of the exhibition wherein the group was described as: 'a variety of Brooches, made after the fashion of those worn by "the daughters of Erin" some centuries ago'. Celtic art was soon assimilated into the melting pot of 19th-century design but was a major source of inspiration for the Arts & Crafts Movement and English Art Nouveau at the end of the era.

Plate 14

Left to right

Brooch or Fibula. A reduced electro-type copy or a cast reproduction of an ancient Irish fibula found at Kilmainham (Co. Dublin) and known as the Kilmainham or Knights Templars' Brooch. The back is engraved with runes and has a registered design mark for 4th July 1849. Made by Waterhouse & Co. of Dublin.
Irish (Dublin): 1849–1853
(V & A 2749–1853)

Brooch or Fibula. A reduced electro-type copy or a cast reproduction of an ancient Irish fibula at one time known as The Moate Pin. Made by Waterhouse & Co. of Dublin.
IRISH (Dublin): 1849–1853
(V & A 2749–1853)

Brooch or Fibula. A reduced electro-type copy or a cast reproduction of an ancient Irish fibula at one time known as The Moor Brooch. Made by Waterhouse & Co. of Dublin and shown at the Great Industrial Exhibition, Dublin in 1853.
IRISH (Dublin): 1850–1854 (V & A 231–1854)

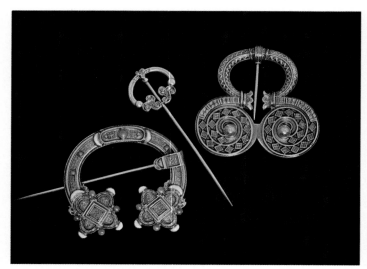

Victoria and Albert Museum

In 1850 the following notice appeared in an edition of the Irish *Conservative* under the heading: Royal Irish Academy, Antique Brooches: 'Amongst the Rare and Beautiful Collection of Antiquities at the Royal Irish Academy are some choice Specimens of Brooches, which were worn by the Irish Chieftains about the 10th century. WATERHOUSE and COMPANY, anticipating that the revival of these brooches of the "olden time" would find favour in the present day, have by registration secured the pattern of two of them, and have already manufactured a great number for the Nobility and Gentry.

'As Shawl and Cloak Fasteners, they are perfectly safe, and in this respect can stand the test with, if not surpass, any modern invention. The stems are not stationary, are secured at the point by the ordinary catch, but revolve similarly to a key on a ring, and, passing through a space left for their admission are afterwards moved round to another position, and rest upon the strongest portion of the Brooch, from which the most violent exercise could not disturb them. WATERHOUSE and COMPANY with pride and pleasure announce that Her Excellency the Countess of Clarendon having been pleased to testify her approval of one of these Specimens of Modern Antique, they have ventured to grace it by the designation of The Clarendon Shawl Brooch, WATERHOUSE and COMPANY, Her Majesty's and His Excellency's Gold and Silversmiths, 25 (?) Dame Street, Dublin.'

Plate 15

Cross pendant. Enamelled gold, the
inner cross of carved lapis lazuli.
Marks: C G, the mark of Carlo
Giuliano of London.
ENGLISH: *c.* 1875

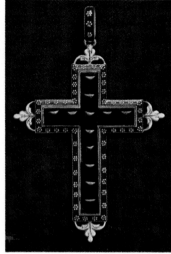

N. Bloom & Son

With a set of jewellery worn by his third wife, Jane Knill, at their
marriage in 1848, and later exhibited in the Medieval Court at the
Great Exhibition in 1851, Augustus Welby Northmore Pugin
(1818–1852) established the character of Gothic Revival jewellery
in England. A convert to Roman Catholicism, Pugin was firmly
committed to the 19th-century religious revival and considered
the Gothic to be the only fitting means for its furtherance.
Though itself secular, the marriage jewellery relates closely both
to his designs for ecclesiastical jewellery and, in its vocabulary of
motifs, to those of metalwork such as chalices. Pugin was known
to be strictly archaeological in his general method but he did not,
in the case of jewellery, go directly to actual medieval prototypes
for his designs. Some of his sources were illuminated manuscripts
and he was clearly greatly influenced by Flemish 15th-century
painters like Van Eyck, whose work he was able to see during his
travels on the Continent in search of material.

The highly influential marriage jewellery was much copied
from the time of its public showing. The firm of John Hardman
and Company of Birmingham which had manufactured the
original set, produced Puginesque jewellery for the International
Exhibition in 1862. Even in Italy the debt to Pugin is obvious in
some designs for brooches in the medieval manner which were
produced in the 1860s. (See Gere pages 56–57) Crosses, which
were such a feature of the second half of the century, were often
elaborate *tours de forces* employing enamels, gems and pearls in
designs which were Gothic in profile only or, as in this elegant
example of the work of Carlo Giuliano, were given a Gothic
flavour by the addition of a detail such as the white enamel trefoils
at the points of the cross.

Plate 16

Left to right:
Brooch (probably once part of a bracelet). Enamelled silver; Joan of Arc (?) in a niche.
Marks: FROMENT-MEURICE, the signature of François-Desiré Froment-Meurice.
FRENCH: *c.* 1844 (V & A M12–1964)
Brooch. Silver; an archangel. Made by F. J. Rudolphi.
FRENCH: (Paris) *c.* 1844. (V & A M341–1962)

Victoria and Albert Museum

Whereas English Gothic Revival jewellery came to be given an ecclesiastical bias under the influence of Pugin and was based on a rigorous intellectual approach, the French equivalent was imbued with the romantic medievalism which was the dominant mood in both countries during the second quarter of the century. The stylistic innovator of the French movement was the goldsmith and jeweller François-Desiré Froment-Meurice (1802–1853) who created a mixed Gothic-Renaissance genre producing pieces of a strongly sculptural quality in marked contrast to the abstract linearity of Pugin's Perpendicular Gothic manner. To ensure a consistently high standard of workmanship in every element of his often highly complex jewels, Froment-Meurice employed enamellers, engravers and sculptors, notably the neo-classical sculptor Jean-Jacques Pradier (1790–1852). Miniature cast figures were incorporated into many of his pieces and those of Wièse, Robin, Morel and others, often forming part of the general structure, and it is this fact plus their subject-matter – largely drawn from romantic tales of medieval knights and their ladies placed in an appropriate architectural setting, and equally romantic interpretations of religious subjects – which so clearly distinguishes the French Gothic Revival from its English counterpart. The style was very popular in France and was well received in England at the Great Exhibition of 1851.

The two pieces illustrated here, the one on the left by Froment-Meurice, the other by the Danish jeweller Rudolphi who was working in Paris, are very restrained and modest examples of a manner which in general produced elaborately wrought and very colourful compositions executed with an exuberant virtuosity.

A set of jewellery in the French neo-Renaissance manner which was being produced concurrently with the Gothic pieces, as described above, is illustrated opposite. It is probably also by Rudolphi.

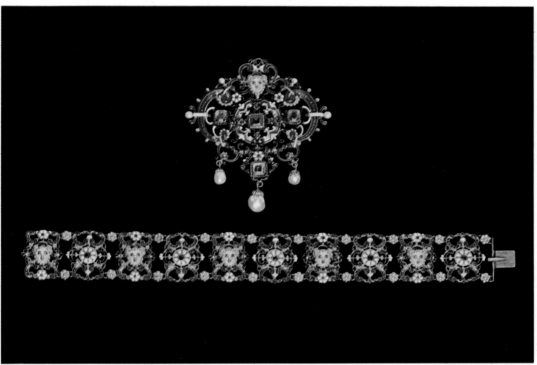

Wartski

Plate 17

Pendant and Bracelet. Enamelled gold
set with sapphires, emeralds and rubies
and hung with pearls; in the French
neo-Renaissance style.
FRENCH: *c.* 1845. Perhaps by Rudolphi,
a Dane working in Paris.

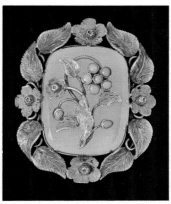

Anne Bloom

Plate 18

Brooch. Two coloured gold, bloomed, chased and set with torquoises in the form of flowers and leaves on a stem, mounted on chalcedony and framed with flowers and leaves similarly treated.
c. 1840–1860

Gold was a favourite material of Victorian jewellers who sought new means of enriching it and introduced two techniques which were new to jewellery. By treating the metal with an acid solution it was possible to vary its surface texture, giving it a soft finish which was called blooming or frosting, an effect which was first used for naturalistic forms but came to be applied more generally.

Further variety was achieved by colouring gold – an idea which was borrowed from the gold box makers of mid-18th-century France who, by making various alloys of gold with other metals – such as copper and silver – were able to create as many as five varieties of gold colour – red, green, blue, white and yellow. A cheaper but less satisfactory 19th-century method was merely to tint the surface of the metal. This brooch has been coloured by the 18th-century method.

Plate 19

Curb-chain Bracelet. Gold. (Attached gold locket not original).
Marks: M&P (unidentified) XVIII (18 carat gold) *c.* 1850

The curb-chain bracelet, like the gold bangle, was popular for most of the period. It adapted itself to the fluctuations of fashion merely by adjusting its size and altering the type and quantity of its pendent additions to suit the current trend. Around the middle of the century this heavy tightly-linked version would have carried a jewelled pendant of some kind, perhaps a cabochon garnet set in gold in the shape of a heart or a padlock, or carved to represent a bunch of grapes with diamond leaves; a number of small coins might also have been suspended from its links. Bracelets were so much favoured at this time that several were often worn on each arm, the curb-chain with its pendants amongst them. By the 1890s it was considerably reduced in scale in keeping with the prevailing taste for small and delicate jewellery. Tiny gold charms or a diamond studded heart replaced the earlier pendant and the chain itself was a fine and loosely-linked. Curb-chain rings date from this time.

Anne Bloom

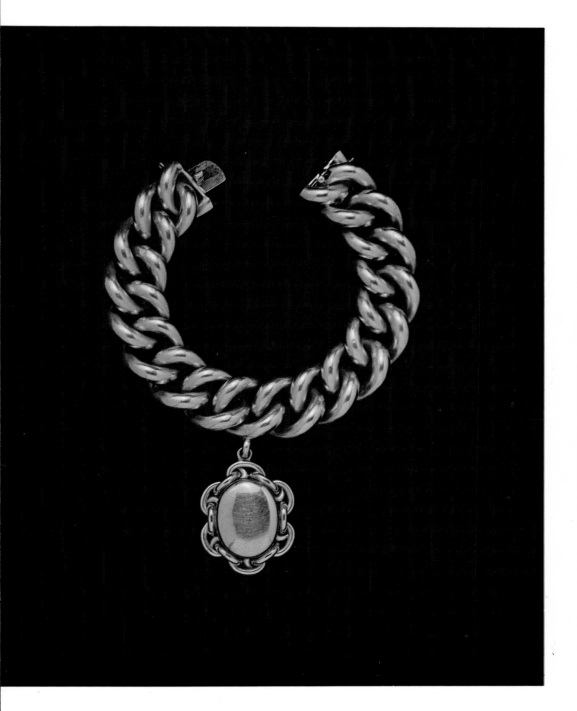

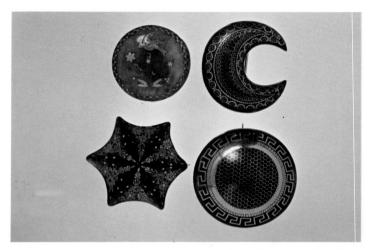

1 & 2 Cameo Corner, 3 & 4 Anne Bloom

Plate 21

Necklace and Bracelet. Silver-mounted agates, moss-agates and carnelians, faceted and polished; the silver mounts also faceted.
ENGLISH or SCOTTISH: *c.* 1850

Attractive geological specimens, faceted and polished, form the basis of this necklace and bracelet and illustrate that particular aspect of Victorian Naturalism which focused attention on mineral and animal products by employing them for making or decorating objects. Many of these raw materials were readily adaptable for jewellery: shells and the coiled ammonite fossil were great favourites as were coral, ivory and tortoise-shell. Bracelets of malachite, 'scotch pebbles' (see Plate 12), even granite (*Art Journal* catalogue of the Great Exhibition 1851 page 220) composed of cylinder-shaped units mounted in silver, often with a pendent heart locket were fairly standard in the early 1850s.

Plate 20

Top row:
Button. One of a set; piqué, in the Aesthetic taste; (see Plate 42).
c. 1870

Brooch. Piqué; in the form of a crescent.
c. 1880–1890

Bottom row:
Brooch. Piqué; in the shape of a starfish with floral decoration in the Naturalistic style.
c. 1850–1860

Brooch. Piqué; with honeycomb and Greek key patterns.
c. 1870–1880

Piqué, the delicate craft of inlaying tortoise-shell and ivory with silver and gold, was introduced into England in the 17th century by refugee Huguenot craftsmen who used the technique to make small decorative objects. In the 19th century tortoise-shell piqué jewellery enjoyed a vogue during the 1860s when it was still being made by hand. The inlaid designs were generally in the floral, naturalistic style. Naturalism occasionally being carried a stage further, to determine the shape, as in the starfish brooch above. Designs of stars were also used. Most frequently found as brooches, buttons or earrings, piqué was also used to decorate the heads of the long pins with which the chignon hairstyles of the 1860s were sometimes adorned. Unfortunately, from 1872, mass-production of piqué commenced in Birmingham and the attractive hand-made pieces such as those on the left of the picture ceased to be made. The mechanized products which replaced them were of a quite different character. Usually inlaid with abstract patterns, their quality both of design and execution was variable, and compared with the hand-made pieces they seem rather dull and coarse.

Su Snodin

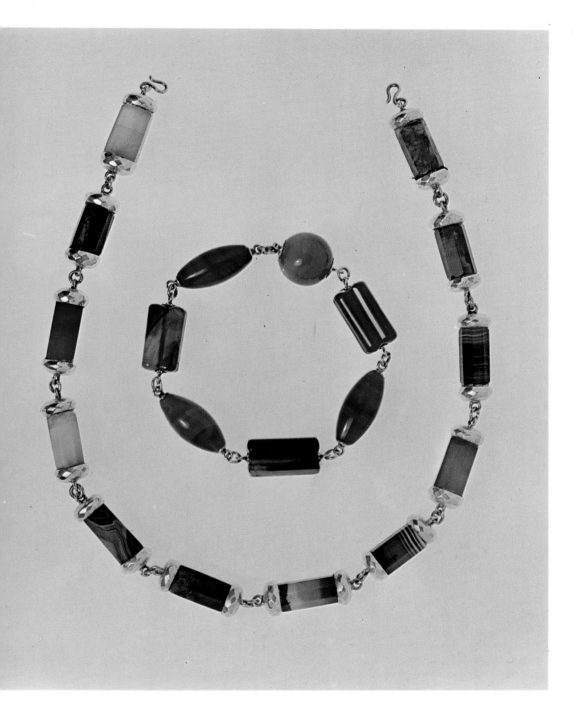

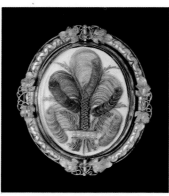

Collection of Mrs Peter Lowry

Plate 22

Mourning Brooch. Hair in the form of the Prince of Wales' feathers, embellished with seed pearls and gold thread; set in a gold-backed swivelling mount and gold frame, with applied leaves and tendrils and gold rope-work.
Height: 2″ (6¼ cm) Max. width: 1¾″ (4½ cm)
ENGLISH: *c.* 1850

'HAIR JEWELLERY, Artist in Hair. Dewdney begs to inform Ladies or Gentlemen that he beautifully makes, and elegantly mounts in gold, Hair Bracelets, Chains, Brooches, Rings, Pins, Studs etc. and forwards the same, at about one-half the usual charge. A beautiful collection of specimens handsomely mounted kept for inspection. An illustrated book sent free. Dewdney, 172 Fenchurch St. London.' (Advertisement, *Illustrated London News*, May 1862).

Sentimental or commemorative jewellery made entirely of, or incorporating, the hair of a loved one, was enthusiastically exchanged by the mid-Victorians to celebrate such important personal events as betrothals, weddings and deaths. The origins of this practice lie in the late medieval custom of distributing mourning rings; a practice which developed in the 17th century to include memorial slides and buckles – exquisite miniatures under faceted crystal, depicting macabre symbols of death's triumph over life and love – followed by the 18th-century versions – all swooning ladies, urns, weeping willows and high-minded inscriptions, in which for the first time fragments of the beloved's hair were actually used as a medium in the picture-making itself instead of being woven into the background as had been the earlier practice. The next development occurred in the middle of the 19th century with the cult of hair jewellery at its height, and the appearance of pictures composed only of hair; pictures small enough to make into jewellery or large enough to hang on the wall; and a full-length, life-size portrait of Queen Victoria at the Paris Exhibition of 1855. Pictures and jewellery were made by both amateurs and professionals for, partly to protect themselves against the malpractice of certain 'Artists in Hair' who were not particular about the ownership of the hair they used, and partly to provide themselves with yet another occupation for their busy fingers, the ladies of the time, armed with a kit, instructions, and pattern book, patiently wove hair into plaits and basket-patterns, and made pictures of flowers, landscapes, and the popular motif of the Prince of Wales' feathers.

Plate 23

Bracelet. Woven hair.
c. 1845
Earrings. Woven hair and gold.
c. 1862
Mourning Ring. Gold and black
enamel; one section contains a lock of
hair under glass. Inscribed:
IN. .ME. .MO. .RY. .OF. Engraved on
the inside: 'Elizabeth Ede died 25th
June 1887'.
c. 1887

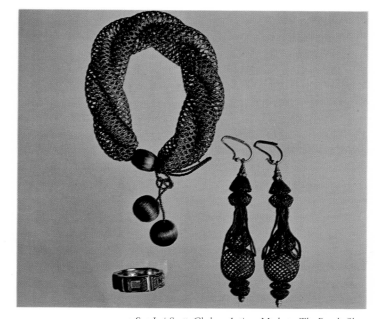

1 & 2 Jeri Scott, Chelsea Antique Market 3 The Purple Shop

Hair jewellery was not always popular; in 1838 some fashion
magazines considered it to be in appalling taste and in the
'aesthetic' atmosphere of the last quarter of the century it was
similarly reviled and the beloved's lock of hair was firmly
relegated to a locket or was just visible beneath a glass on a black-
enamelled ring. But while the craze lasted hair jewellery
abounded in every shape and form: fine rings and long spyglass
chains; thick plaited bracelets two inches wide, finished with
chased or enamelled gold buckles set with a cabochon garnet or
turquoises, perhaps in the form of a serpent's head; bracelets made
from coiled tubes of open basket-weave and pendant earrings of
delicately poised spheres tipped with gold. Other types of
mourning jewellery were continuously in demand in the second
half of the century, due to the long and strict mourning observed
by the Queen after the death of her consort Prince Albert in 1861,
and manufacturers of sombre jewellery found themselves in a
lucrative industry. Ladies being presented at Court were required
to wear black jewellery and the general public followed suit; strict
mourning etiquette was observed by all and mourning, in a sense,
became fashionable. Jet, the hard glass substitute known as
'French Jet', tortoise-shell and the Irish bog-oak were all
acceptable and were produced in all the styles of popular
jewellery; the black onyx stone was used extensively. The jet
industry at Whitby in Yorkshire flourished; by 1873 over 200
workshops were producing enough to supply the home market as
well as exporting to the Continent, the United States and the
Empire.

Plate 24

Brooch. Silver set with diamonds; in
the form of a bouquet of flowers and
leaves with three detachable drops
à pampilles.
Probably ENGLISH: *c.* 1850

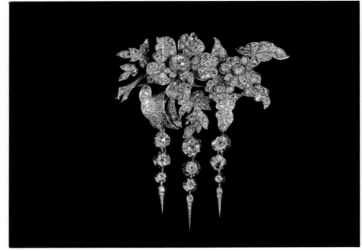

Cameo Corner

The 18th-century fashion for floral corsage ornaments of precious
stones, parts of which were set on small springs and quivered at
every movement of the wearer, continued into the 19th century
with the addition of the cascades of stones known as *pampilles* – a
French innovation of the 1840s.

This diamond brooch of about 1850 typifies the rather tentative
application of the new setting which one would expect of the
conservative English designer of expensive formal jewellery. For
it was the French *joailliers* of the late 1840s and 1850s who were
fully to develop its possibilities with their extravagant hair
ornaments known as *coiffure en joaillerie*. From wreath-like
diadems of naturalistic flowers and leaves, the *pampilles* rippled
down either side of the face mingling with ribbons and the
wearer's own curls. These hair ornaments were worn *en parure*
with matching brooches at corsage, waist and shoulder, each
complete with its glittering waterfall of gems, the whole thing
executed in enamelled or bloomed gold (see Plate 18) set with
pearls and precious stones imitating the natural colours and
textures of flowers and foliage. Stars sometimes appeared amongst
the flowers and a parure by Julienne called *La Voie Lactée* consisted
of a multitude of stars of various sizes.

Plate 25

Brooch. Enamelled silver set with diamonds; with three pendants, of which the central one is detachable. Probably ENGLISH: *c.* 1851

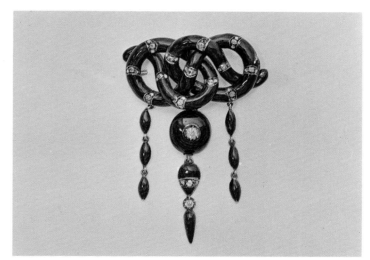

N. Bloom & Son

The highly decorative serpent jewellery of the 1830s was later joined by a more realistic kind in which the serpentine coils of two gold snakes, chased in life-like imitation of snakeskin, formed a loose knot at the centre of certain brooches and bracelets. An abstraction of this form can be seen in this brooch of Prussian blue enamel which is set with bands of diamonds and hung with drops *à pampilles*. The enamel is given added brilliance by being laid over silver foil. Jewellery of a similar type was exhibited by the firm of Watherston and Brogden at the Great Exhibition of 1851.

Plate 26

Brooch. Carved coral and gold, in the form of a flower with buds and leaves on a chased gold stem.
Probably ITALIAN: *c.* 1850

Bracelet. Carved coral and gold; the central unit in the form of a head of Dionysus (Bacchus) flanked by attenuated lions' heads which form the side pieces.
FRENCH: *c.* 1850

Shrubsole Phillips

Coral, which in its natural state had long been worn in Italy as an amulet, began in the 1830s to be exploited for its decorative appeal in conventional jewellery. Though coral was for a time a speciality of that country, it was an English jeweller, Robert Phillips (*d.* 1881) who was credited with popularizing coral jewellery, for which service he was decorated by the king of Naples.

In shades of pale pink and red, coral was used alike by master jewellers such as François-Desiré Froment-Meurice (see his set of a pendant and pair of brooches, of about 1854, in the Victoria and Albert Museum [M30-b-1962], in which the coral is carved *en cameo* and set in a neo-Renaissance frame hung with pearls); the manufacturers of 'popular' jewellery (see Plate 10); and peasant jewellers. It was incorporated into jewellery in the classical manner (see Plate 34); and turned and polished to make beads of every size for use in spectacular parures. During the early 1850s, affected by the current taste for three-dimensional Naturalism, coral was frequently carved to represent flowers, buds, and leaves in the round, and set in gold mounts chased to simulate the surfaces of stems and twigs. At the same time the spiky branches of coral in its natural state were made into fantastical tiaras and corsage ornaments (both the Victoria and Albert Museum and the London Museum have examples of these). Coral was still popular in the 1860s and in 1867 there was a great deal of it to be seen in the Castellani Collection of Italian Peasant Jewellery shown at the Paris Universal Exhibition of that year.

Plate 27

Bracelet. Gold, enamelled, chased and set with diamonds; in the form of a twisted branch bearing fruit and leaves.

Marks: C S in an oval: 56 (ie 56 zolotniks, the Russian gold standard). CS is the mark of Carl Siewers, the St. Petersburg jeweller and silversmith whose work is recorded between 1849 and 1860. Examples of his work can be seen in the State Historical Museum, Moscow.

RUSSIAN: 1850–1860

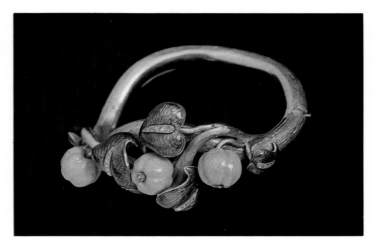

N. Bloom & Son

With Naturalism at its height in the middle of the century there was an international fondness for jewellery in the form of twigs or branches fully modelled, and laden with fruit, flowers and leaves. The colours of nature were suggested by enamels and coloured precious or semi-precious stones, and its textures by chasing, engraving, etc.

Plate 28

Bracelet. Gold mesh in the form of a
garter with a detachable brooch of
black enamelled gold set with
diamonds and emeralds, and a tab of
chased gold, also enamelled and gem-
set.
FRENCH or ENGLISH: 1860–1865

Bracelets were consistently worn, singly, in matching pairs, or
grouped in a carefully composed arrangement of the kind advised
in the *World of Fashion* in 1844: 'on one arm is placed the
sentimental bracelet, composed of hair, and fastened with some
precious relic; the second is a silver enamelled one, having a cross,
cassolette, or anchor and heart, as a sort of talisman; the other arm
decorated with a bracelet of gold net work, fastened with a simple
nœud [knot], similar to one of narrow ribbon; the other
composed of medallions of blue enamel, upon which are placed
small bouquets of brilliants, the fastening being composed of a
single one; lastly, a very broad gold chain, each link separated
with a ruby and opal alternate'.

The flexible bracelet was joined in the second half of the
century by a multitude of inflexible bangles: from hoops of
unadorned gold to the many hinged and often close-fitting types
which reflected every passing trend in ornament and design right
through to the 1890s and – in smaller, lighter versions – beyond.
Amongst these appeared the manchette, a wide cuff, composed
sometimes of thin bands of metal, sometimes a stiff frill of gold 2″
wide (see Victoria and Albert Museum M103-1951).

Much earlier a type of bracelet, enamelled to simulate ribbon,
buckled, folded, or knotted, had first appeared in England in the
1830s and was popular both in France and England from the
1840s to the 1860s – when it was often enriched with jewelled
tabs, fringes and pendants. The gold mesh bracelet illustrated here
with its detachable brooch and gem-set tab is of the type known
as a *Bracelet Jarretière* [garter] and dates from the early 1860s.

Plate 29

Bracelet (*Left*). Enamelled and chased
gold set with garnets; of polygonal
shape.
FRENCH or SWISS: *c*. 1845

Bracelet (*Right*). Enamelled gold set
with rubies (originally diamonds) and
pearls; consisting of ten articulated
sections, five of which are in open-
work.
FRENCH: possibly by Frédéric
Boucheron (1830–1902) of Paris.
(cf Victoria and Albert Museum
747–1890).
c. 1860–1870

French involvement in North Africa following upon its conquest
of Algeria in 1830 gave rise to a taste for the Moorish in France,
which became evident in jewellery design from the 1840s to the
1870s. While some French jewellers were designing pieces entirely
in the *genre Marocain* (see Vever Vol. I page 154 and Vol. II page
186, work by Bourdillat and Crouzet respectively), various motifs
– some of them borrowed from Algerian dress – the 'Algerian
knot', tassels, fringes and looping chains, were also being applied
to the currently popular European styles such as the Rococo
Revival (see Plate 7) and the neo-Etruscan (see Plate 37). Other
pieces like the bracelet on the right were given a Moorish flavour
by various decorative means such as the use of the characteristic
interlacing ornament, the arabesque and pseudo-Arabic
inscriptions. The taste for this type of jewellery spread to England
and to other parts of Europe. Bracelets of polygonal form, like
the one on the left, became popular towards the middle of the
century.

N. Bloom & Son

Plate 30

Pendant. In the Holbein style; enamelled gold set with emeralds, pearls and diamonds; the gold chain having enamelled gold links enriched with pearls. The reverse is engraved with floral motifs and foliage in the manner of Tudor pendants.

ENGLISH: early 1860s. Similar to the work exhibited by Robert Phillips of Cockspur Street at the International Exhibition of 1862.

The profusion of stylistic groups listed in the official catalogue of the Great Exhibition of 1851 included items of jewellery described as being in the style of Holbein. Jewels of this type have, amongst the neo-Renaissance group, a distinctive style which is an attempt to recapture the spirit of the Tudor courtly jewels with which Hans Holbein the Younger (1497–1543) – for a time court painter to Henry VIII – is associated.

In the historicizing atmosphere of the 1850s and 1860s Holbein was cited – in the area of jewellers' and goldsmiths' design – as the great master from England's golden age. Students and craftsmen were exhorted to study and emulate his work; in 1869 The Arundel Society for Promoting the Knowledge of Art published a series of twelve photographs of original Holbein drawings in the British Museum (many of them designs for pendants) 'for the use of Schools of Art and Amateurs'.

The Holbein pendants of the 19th century were generally of oval or diamond shape with an enamelled and jewelled border – which was sometimes decorated with stylized Tudor roses – framing a large gemstone or group of stones or pearls suspended in an openwork composition, or occasionally a cameo; a further gemstone mounted in gold, or a pearl, depended from its lowest point.

Essentially of abstract design which relied for its effect on the rich contrasts of coloured stones, enamel and gold, the Holbein pendants are easily differentiated from the ornate and highly sculptural ones which were inspired by the Italian Renaissance. (See Plate 31). A number of pendants and other pieces in the Holbein style were shown both at the International Exhibition in London in 1862 and the Universal Exhibition in Paris in 1867; the type was firmly established and remained part of the repertoire of English Victorian jewellers who were still at the turn of the century giving it a new interpretation in the light of current trends.

Plate 31

Pendant. In the neo-Renaissance style; enamelled gold set with emeralds, garnets and pearls, with an aventurine cameo of Minerva, the Roman warrior-goddess.
FRENCH or ENGLISH: late-1860s

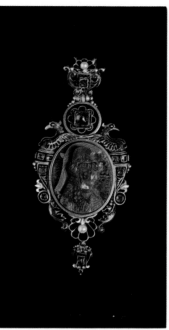

N. Bloom & Son

Nineteenth-century neo-Renaissance jewellery was, at times, of such superb quality that it has, often, been mistaken for its 16th-century and 17th-century prototypes by the unpractised and even, on occasion, the practised eye. The skill of some of the goldsmith-jewellers at duplicating this work is borne out by the fact that 'Renaissance' jewels have been discovered which were in fact made within the last 140 years. Convincing examples by prominent jewellers can now be dated from the 1880's and later. It is interesting to note that René Lalique – a name which has become synonomous with Art Nouveau – exhibited a neo-Renaissance brooch at the Paris Salon of 1895.

Confusion also arises from the fact that in certain instances the motivation behind this kind of jewel was the desire to create an appropriate setting for a genuine antique cameo of classical or 16th-century date. While it is tempting to dismiss these 'compositions' as deliberate fakery, it is important to remember the genuine reverence for historical objects and the wish to restore them, if damaged or incomplete, as nearly as possible to their original state.

The reverse view (below) illustrates the extent to which this piece is true to its precursors in the late-16th and early-17th centuries. Conceived, correctly, as a piece of miniature sculpture, it is fully modelled and richly engraved and would look equally good from the back as from the front but for the omission of counter-enamelling, that is the enamelling of the reverse, which would have made it a truly three-dimensional jewel. The locket compartment situated behind the cameo is of course a further 19th-century departure from the Renaissance type.

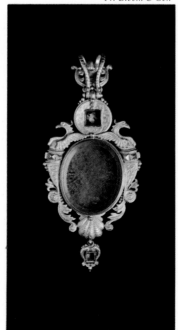

S. J. Phillips

Plate 32

Necklace and Earrings. Enamelled
gold set with diamonds, rubies, and
pearls.
Marks: C G, the mark of Carlo
Giuliano of London.
ENGLISH: late-1860s

Enamelling, an aspect of the jeweller's art which had been
virtually neglected since its heyday in the 17th century, enjoyed a
considerable revival during the second half of the 19th century.
For pieces in the neo-Renaissance manner it was a requisite part of
the jeweller's equipment and it was also an important feature of
Naturalism. Its most talented and influential exponent in England
was unquestionably the Neapolitan goldsmith and jeweller Carlo
Giuliano, who came to this country as a protegé of Robert
Phillips, and worked for other jewellery firms before setting up
his own premises at 115 Piccadilly in 1874. He died in 1895,
leaving the business to his sons Carlo and Arthur with Pasquale
Novissimo as chief designer to the firm.

Giuliano was highly praised for his work in Castellani's
archaeological neo-Etruscan style, having mastered the intricate
granulation technique, and it is possible that he worked closely
with Alessandro Castellani during his stay in England. He
developed a distinctive style of enamelling which was in the
tradition of the 16th and 17th centuries and at its best his work
equalled that of the earlier craftsmen. He was much imitated in
the later years of the century.

This necklace and earrings, which are a typical late-1860s
pastiche owing something to the High Renaissance, are an
unusually flamboyant example of his work but as an exempli-
fication of his mastery of the encrusted enamelling technique
deserve a place here. This set can be related to a pendant in the
Victoria and Albert Museum (164-1900), which was shown at the
Paris Universal Exhibition in 1867 under the aegis of the firm of
Harry Emanuel of London for whom Giuliano was then working.

Plate 33

Earrings. Gold, with applied ornamental beading and rope-work. In the form of a head of Hera (Juno) wearing an applied diadem, earrings, and necklet.
ITALIAN: *c.* 1862. Marked with the crossed 'C's monogram of the Castellani workshop.
Height: 1½″ (3·2 cms)

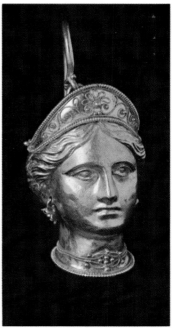

S. J. Phillips

'As ardent followers of art, and enemies of all privilege, we do not think that our labour for the cultivation of a purer taste in jewellery by the revival of ancient forms will be lost; and remembering the beautiful adaptation long since made of the philosopher's words, "They who hold the lamps (of knowledge) will hand them on to others" [Plato] we do not reserve everything for ourselves, being fully satisfied in the thought that others will follow us, and, progressing in the road we have chosen, will help to recall the attention and admiration of the modern world towards worthy objects.' Thus Augusto Castellani (1829–1914) concluded *Antique Jewellery and its Revival* which was published in England in 1862. In so doing he gave expression to the idealistic intentions which had sustained more than thirty years of scientific and archaeological studies into classical jewellery excavated in Italy; studies which had been instigated by his jeweller father Fortunato Pio Castellani (1793–1865) and continued by his brother Alessandro (1824–1883) and himself, both of them archaeologists and goldsmiths.

The Castellani workshop in Rome created jewellery which exactly reproduced known classical types and proved to be the starting point for a fashion for neo-Greek and neo-Etruscan jewellery which was to become one of the principal modes of the Victorian period. Amongst the craftsmen employed were some whom Fortunato Pio Castellani had brought to Rome from a remote region called St. Angelo in Vado, where they were reputed to have been working in techniques which had been carried on since the days of the ancient Etruscans.

At the 1862 International Exhibition, a small cramped case containing the work of the Castellani attracted a great deal of attention and both professional and popular praise. It was the first opportunity for the rest of Europe to survey their remarkable craftsmanship and versatility, though the firm had been producing jewellery based on an archaeological approach to various earlier periods for some time. The case was divided into several compartments containing specimens in the Greek, Etruscan, Roman, Medieval and Renaissance styles and, in spite of its poor arrangement – according to *The Jewellers', Goldsmiths', Silversmiths' and Watchmakers' Monthly Magazine* – it nevertheless 'engaged the monitorial services of a policeman in order to [ensure] its preservation and the preservation of order around it . . .'. In its description of the contents of the case the magazine goes on to cite a pair of earrings 'with the head of Juno (the originals of which were found at Kertch in the Crimea) [which] are heavy for Greek ornament, and are chiefly remarkable as

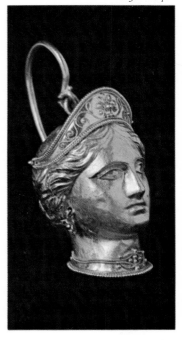

examples of *repoussé* work as practised by the Greeks.' While it is tempting to regard the foregoing as a possible description of the earring here illustrated, one must bear in mind that very few Castellani pieces of this kind were unique. However further interest is attached to this example of their work by the fact that a pendant of Hera, said to have been found at Kertch, can be seen amongst the collection of classical Greek jewellery at the Victoria and Albert Museum (8487-1863). The similarity is striking and suggests that the Victoria and Albert Museum's pendant is of the kind which provided the Castellani prototype.

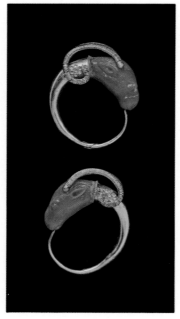

S. J. Phillips

Plate 34

Earrings. Gold and coral; with coral ram's head terminals and twisted gold wire horns.
Marks: N P: unidentified; and another indecipherable.
Possibly FRENCH or ITALIAN: 1870s

Forced into political exile by the events in Italy, Alessandro Castellani visited London and Paris, and must certainly have instructed some of the eminent goldsmith-jewellers of both cities in the results of his family's lengthy researches. For during the 1860s and 1870s both French and English versions of the Castellani archaeological styles employing their techniques of filigree and granulation began to appear. In Paris the chief exponent was Eugène Fontenay and in England, Robert Phillips, Carlo Giuliano, Carlo Doria and Giuliano's assistant Pasquale Novissimo, together with John Brogden, formerly of Watherston and Brogden, all worked successfully in these techniques, producing pieces of a high standard of execution. The style rapidly became international and as very few of the pieces are marked or signed it is usually impossible to identify them precisely or to ascribe them positively to a particular maker.

The necklace illustrated, with its amphora-shaped pendants, is of excellent quality and is a superior version of a popular Etruscan type which was probably produced in great quantity by the commercial jewellers. The ram's head earrings are based on a well-known classical form, the originals of which were usually rendered entirely in gold.

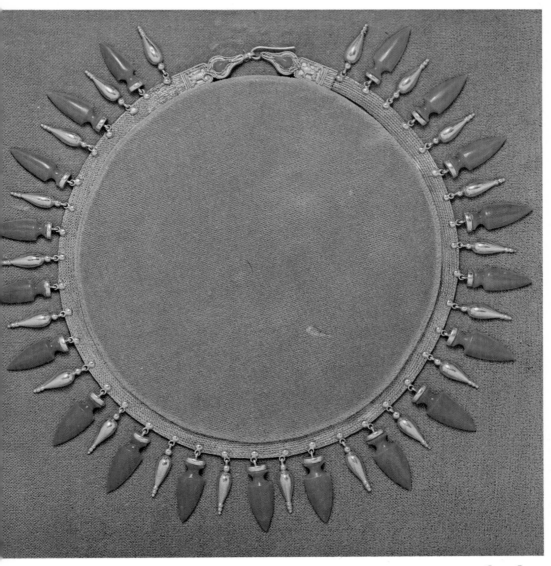

Cameo Corner

Plate 35

Necklace. Gold and coral; in the neo-Etruscan style, with alternating coral and
gold amphora-shaped pendants on a fine gold mesh band. The tabs are decorated
with applied gold frogs and a coral bead surrounded by gold rope-work.
FRENCH, ENGLISH or ITALIAN: 1860s–1870s

49

Plate 36

Necklet with pendant and earrings.
Enamelled gold set with cabochon
garnets, decorated with stamped
classical palmettes and applied rope-
work and beading.
Probably ENGLISH: mid-1860s

With its oval pendant swinging from a knitted gold chain, this
set of jewellery in the commercial, as opposed to the
archaeological, neo-Etruscan manner is typical of a profusion of
jewellery in this vein which appeared at the International
Exhibition in 1862 and was later taken up by the women of the
1860s to wear with their heavy crinolines. With bare neck and
shoulders allowing sufficient space for these emphatic jewels to be
seen at their best, the hair was swept up into a high chignon
which was also dressed with a classically-inspired comb or narrow
diadem or with long pins. What could have been a severe
hairstyle was usually relieved by a flurry of curls at the hairline
and a further series of long ringlets falling from the chignon to the
nape of the neck.

The machine-bright precision of these pieces ensures that they
are not easily confused with classical jewellery, allied to the fact
that in the commercial field there was little, if any, attempt at the
verisimilitude which informed the work of the 'archaeological'
jewellers like Castellani and the Frenchman Eugène Fontenay
(1823–1887).

Shrubsole

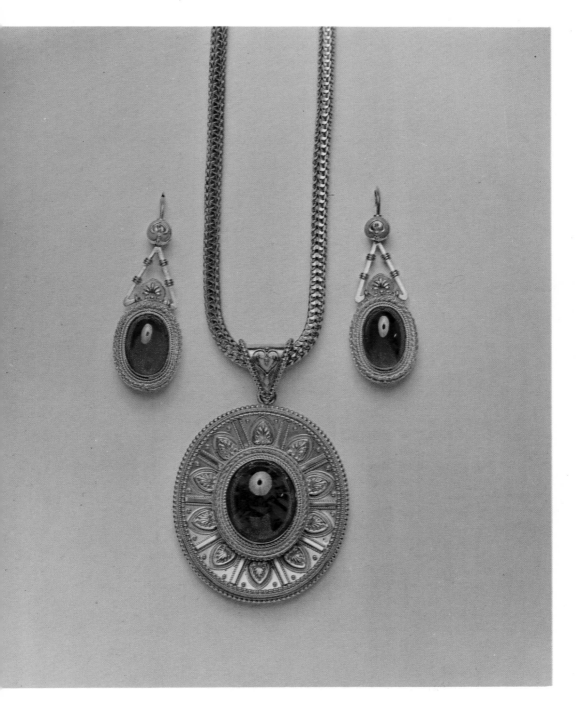

Plate 37

Earrings. Gold set with *pavé*-set turquoises; the two units are linked by the anthemion motif and hung with a palmette and a gold drop.
Probably FRENCH: 1870s

Pendant. Enamelled gold set with pearls and hung with a gold fringe. There is a locket compartment on the reverse.
Probably ENGLISH: 1860s

Bracelet. Malachite bosses mounted in interlinking gold units which are decorated with applied ropework and *canetille*.
Probably FRENCH: 1860–1870

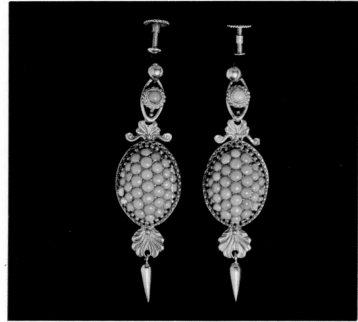

Bloom *Cameo Corner*

52

The bracelet (*left*), though unlikely to be the work of Castellani –
it is unsigned and the goldwork is of a French character – very
probably derives from a Castellani type. This consisted of oval
gold units with applied decoration which contained bosses,
plaques, scarabs, etc. and were linked by cylinder-shaped units
(see Bibliography: Flower, *fig.* 92c; Bradford page 46; and Gere
figs. 52a and b). The bracelet illustrated may, by its use of
malachite in conjunction with this setting, indicate that
Alessandro Castellani acted upon the suggestion of his friend and
collaborator Michelangelo Caetani, Duke of Sermoneta, which
was contained in the following letter quoted by Charlotte Gere in
Victorian Jewellery Design (see Bibliography): '. . . I enclose an
artistic novelty that I have recently produced, which may also be
of some use to our jewellery work since it enobles malachite,
which has been so misused by the unenterprising jewellers of the
Via Condotti. By turning it on a lathe, I have produced a number
of buttons, which can be set in brooches and used in other ways,
to give the effect of antique jewellery; for that reason I have used
malachite that is uniform in colour, resembling turquoise, which
looks like ancient copper or patinated bronze. Small round saucers
[?"*piccole patere*"], nails and ornamental bosses can be made from
it. If you want to use these buttons you can easily design a setting
for them.'
 Long dangling earrings featuring various motifs from the
classical repertoire and the numerous permutations of these, were
worn throughout the 1860s and for most of the 1870s. These
pretty turquoise ones represent a typically muddled association of
motifs and materials and probably date from the 1870s when
there was a revival of these stones.
 Mass-produced jewellery in the neo-Etruscan style continued
to be made in ever-weakening and more remote versions of the
original archaeological forms for the remainder of the century.
This pendant dates from the early 1860s when recognizable
popular forms began to emerge after the International Exhibition
of 1862. The fringe was an addition of this time and may be
connected with the taste for Algerian jewellery in France (see
Plate 29).

Anne Bloom

Plate 38

Pendant in the Egyptian manner.
Gold and mosaic.
ITALIAN (?): late-1860s

A revival in Europe of the 18th-century taste for Egyptian architectural forms and ornament came about early in the century following upon the widespread publication (in 1809) of the archaeological findings of Napoleon's campaign in Egypt in 1798, and of Baron Vivant-Denon's journey there, which was published in 1802. In England at that time, attempts at archaeologically correct 'Egyptian' design, such as Thomas Hope's Egyptian Room in Duchess Street, London (1800–1807), were comparatively rare, and only possible because the designer had himself visited the country; although a number of Egyptian antiquities were already to be seen at the British Museum. But as a source of inspiration and a subject for study, ancient Egypt quickly established itself and by the 1830s both in Europe and America the Egyptian manner was a pervasive influence on architecture and all kinds of artefacts. Sustained by numerous articles and illustrated books and by such events as the opening of the Egyptian Room at the Crystal Palace in 1854, a fondness for the Egyptian style continued throughout the century reaching a peak in the late-1860s when a flurry of Egyptiana heralded the completion of the Suez Canal. Its effect on jewellery at this time was wide-ranging; from the lavish French diamond-set parures of Fontenay and Lemmonier, Egyptian in theme and general outline only; to the careful near-reproductions of Castellani, Brogden, and others whose models were the archaeological finds in museums; to the many pieces somewhere in between which, like the pendant illustrated, recapture the vibrancy and colour of Egyptian jewellery by using a mixture of derived motifs rendered in appropriate materials, but make no attempt at archaeological accuracy. Later, in 1885, a report reveals a novel fashion with the reappearance of the ancient Egyptian *oudja* as a luck jewel. 'It was a fashion in Egypt some 3,000 years ago. It consists of a large eye, with eyebrow, and also with a tear glistening in it. It is encased in silver and is worn like a locket.' In 1890 the great success of Sarah Bernhardt as Cléopatre in Moreau's play was responsible for a fashion for jewellery made of oxidized silver set with torquoises which was based on the stunning 'Egyptian' ornaments worn by Bernhardt in the play.

N. Bloom & Son

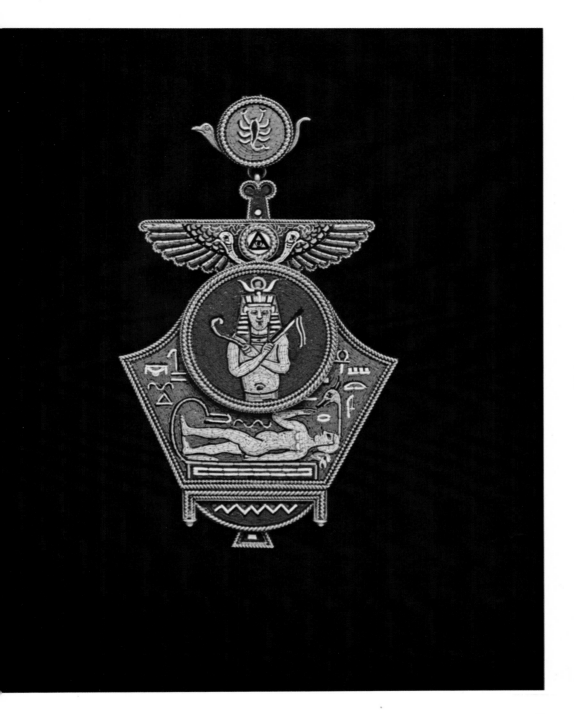

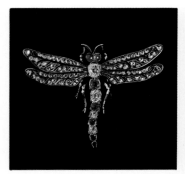

Cameo Corner

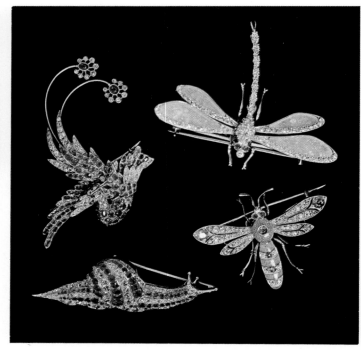

Plate 39

Top row left to right:
Brooch. Diamonds and rubies set in silver strengthened with gold; in the form of a dragonfly.
Late-19th century

Brooch. Sapphires, emeralds, rubies, and diamonds set in gold; in the form of a bird of paradise.
Probably FRENCH: late 1860s. Similar in treatment to the peacock brooch shown by Beaugrand at the Paris Universal Exhibition in 1867.

Brooch. Opals, diamonds and rubies set in gold; in the form of a dragonfly.
Late-19th century

Bottom row left to right:
Brooch. Diamonds, emeralds, rubies set in silver and gold; in the form of a snail.
1870–1880

Brooch. Diamonds, emeralds and rubies set in silver and enamelled gold; in the form of a wasp.
1860s

The jewelled birds, butterflies, beetles and insects of all kinds which had first appeared in the hair and scattered on bonnets and veils in the early sixties became a rage during that decade, both resuming and developing an 18th-century fashion. It was a fashion which was to continue in one form or another right through to the 20th century and Edwardian jewellery. Some of the early examples were conceived and treated naturalistically with enamels and gems which loosely approximated to their colours in nature. Late in the century when colourful jewellery was considered garish, diamonds were combined with opals in flatter, more attenuated versions. Garnet or ruby eyes were the only concession to colour and at most a modest sprinkling of sapphires or emeralds decorated the bodies and wings. Insects, birds, etc. appeared amongst the many novel motifs of the 'popular' jewellery of the nineties (see Plate 48) while at the same time they were being given radical new forms by the artist-jewellers of Art Nouveau.

Plate 40

Brooch. Silver; two hearts entwined beneath a crown.
Marks: I N S: the silver mark of Inverness.
 F B: divided by a diamond-shaped device, probably Ferguson Brothers of Inverness.
SCOTTISH: *c.* 1870

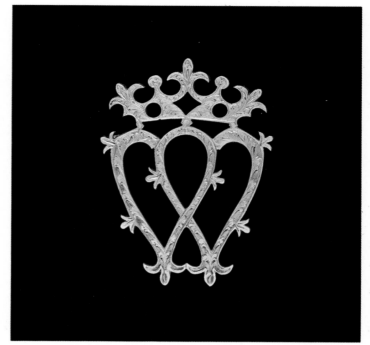

Private Collection

Dating from the seventies, this 'Luckenbooth' brooch – so called because its 18th-century precursor was sold in the Luckenbooths (locked booths) from which the jewellers traded around St. Giles Kirk in Edinburgh – is of a traditional betrothal type which can be traced back to the simple heart-shaped love brooches of 14th-century France and England. The Scottish 18th-century type, which was also worn as a protection against witches, strongly resembled these medieval originals, but early in the 19th century a heavier, engraved version emerged. Consisting of two hearts joined beneath a crown, these brooches continued to be made throughout the century and have been popularly but erroneously identified with Mary Queen of Scots, due no doubt to the 'M' shape created by the entwined hearts and to the presence of the crown. Some 18th-century pieces still bore the marks of itinerant silversmiths but their large-scale production by the 19th-century city jewellers finally removed them from the realm of folk art to merge with the popular commercial trends of the day. Thus their essential simplicity was often lost beneath encrustations of semi-precious stones, polished agates or pastes; the truer modern versions being the Gothicized type like the one illustrated.

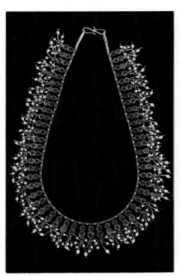

S. J. Phillips

Plate 41

Necklace. Rubies, sapphires and pearls mounted in enamelled gold; in the Indian manner.
Marks: CG on the clasp: the mark of Carlo Giuliano of London.
ENGLISH: 1880s

Evidence in the 1880s of the growing dissatisfaction with the ornate, geometrically precise, and by now thoroughly predictable, commercial jewellery of the high Victorian period was revealed by a new enthusiasm for the irregularities and exoticism of the hand-made jewellery from India which could be seen at the Industrial Arts of India Exhibition which was held in London in 1886. The public, both in Paris and London, had been able to view similar work on several previous occasions since its first showing in 1851, but by the eighties, with Queen Victoria now Empress of India, interest in that country was heightened and people began collecting Indian jewellery to wear rather than merely for its curiosity value.

Major French and English craftsmen like Alexis Falize and Robert Phillips had experimented with the Indian idiom since the late sixties. A necklace by Phillips Brothers of Cockspur Street which was acquired by the Victoria and Albert Museum (549-1868) after its showing at the Universal Exhibition in Paris in 1867 shows how closely he was able to imitate the Indian enamelling technique. While with the superb necklace illustrated here, Carlo Giuliano has created a piece which, though superficially Indian in form and feeling, differs in its execution in several important respects, namely: the settings of the stones, which are open and perfectly circular where they should be irregular, probably tear-shaped, and closed at the back; the colouration, which would be more convincing with the addition of the brilliant green of emeralds, and finally the embellishment of the gold links with Giuliano's distinctive, and unmistakably European, touches of black and white enamel.

The taste for jewellery on an Indian theme was further expressed by such novelties as necklaces and bracelets composed of tiger claws mounted in gold.

Plate 42

Bracelet. Five Indian portrait miniatures in gold filigree mounts similar to the French type known as *canetille*.
INDIAN: mid-19th century

Necklace and Brooch (part of a parure): Plaquettes of green glass over gold foil depicting hunting scenes, mounted in gold settings which are probably Indian in origin. The central drop of the necklace, which shows a floral motif, and the brooch are both mounted similarly to the bracelet above and have been added from another source.
Marks: 14K (on bracelet — not shown).
INDIAN: *mid-19th century*

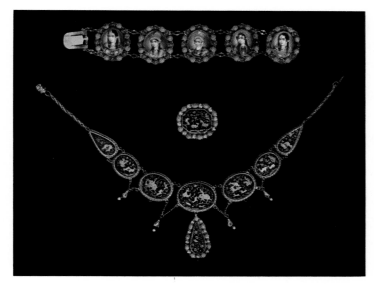

S. J. Phillips

Indian jewellery was imported into England by Arthur Lasenby Liberty (1843–1917) after 1875 when he opened his Oriental Warehouse in Regent Street. The shop was a favourite haunt of the Pre-Raphaelites and their following who, scorning current fashions in both clothes and jewellery, wore long flowing dresses, strings of amber beads, and were much taken by the 'aesthetic' quality of oriental and antique jewellery as depicted in the paintings of Dante Gabriel Rossetti (1828–1882). The bracelet (top) may well have been made by an Indian craftsman attempting to imitate French settings for the European market, as the gold filigree elements closely resemble the *canetille* of the first half of the 19th century in France, but are markedly dissimilar in their execution.

The green glass work of the necklace and brooch, which is not unlike the fragile 17th-century European *émail en résille sur verre* in appearance, is known as 'Indian pitch' and is made by pouring green glass onto the gold foil cut-outs in a mould. Once set, the glass is polished until level with the surface. In this case the setting appears to be authentically Indian (with the exception of the brooch and the central pendant unit of the necklace both of which are mounted in a form of *canetille* like the bracelet above).

These plaquettes are known to have been imported unmounted into England; one such, in a mount marked Watherston & Brogden, was shown in the 'Slave to Siren' Exhibition of Victorian jewellery in the United States in 1971 (see Bibliography).

1 & 2 Mrs. Elizabeth Bonython 3 Dibdin

Plate 43

Top and bottom:
Two Brooches. *Shakudo* work, a Japanese technique originally employed for sword-mounts in which an alloy of gold and copper is cast in relief, blackened by 'pickling' and then encrusted with gold and silver. The brooches are in the form of fans decorated with cranes, orange blossom, marine animals, and vegetation in relief.
JAPANESE: probably made for the European market.
1870s

Centre:
Brooch. Silver, engraved with a crane, bamboo stalks, bullrushes, and foliage.
Probably ENGLISH: 1880s

With the resumption of trade relations between Japan and Europe, the formal beauty of Japanese art could be widely appreciated for the first time when Japanese art and artefacts were shown at the International Exhibition in 1862. By the late sixties Japonisme was proving to be the necessary revitalizing force capable of bringing back to design – which had now, due to the rapid commercial expansion, atrophied into mindless repetitions of revived styles – a consciousness of beauty and quality. More than just another exercise in 19th-century eclecticism, Japonisme was to have far-reaching effects upon European art and design for the rest of the century. As far as jewellery design was concerned this applied particularly to Art Nouveau at the turn of the century but prior to that the movement had already had an impact upon the general jewellery scene. Imported Japanese brooches such as those pictured at top and bottom of the plate, had, like Indian jewellery, a cachet for the aesthetically-orientated followers of the Pre-Raphaelites and very soon silver brooches, some of them encrusted with gold and copper in imitation of Japanese *Shakudo* work, began to be made in England. Typical examples were engraved or applied with such 'Japanese' motifs as cranes, orange blossoms, bamboo and bullrushes, marine animals, and abstract linear patterns. A favourite shape was the fan.

Inevitably under commercial pressures the originally pure forms became debased, either by being larded with diamonds and enamel and mixed with other unrelated motifs, or by the diluting effects of mass-production, so that by the nineties, with the silver and gold bar brooches emblazoned with girls' names and coy mottoes, one finds only a faint echo of the technique combined with a total ignorance of the original intentions.

Plate 44

Necklace with pendant cross. Gold-mounted amethysts and pearls.
ENGLISH: 1870–1880

In the last quarter of the century with the growth of interest in gemmology, precious and semi-precious stones were mounted in unbacked, cut-down settings which allowed the light to filter through them, and the full benefit of their actual colours to be appreciated, without the distraction of the elaborate settings which had obtained earlier in the period. The pendant cross of this amethyst necklace has been given an appropriately Gothic feeling through setting the central stone in a series of slightly rounded arches set with pearls and edged with applied gold granules; a feeling which is carried through to the points of the cross, each of which is applied with a pearl and granules in a formation which is suggestive of the Gothic trefoil. The use of the gold granules shows the lingering influence of the neo-Etruscan style.

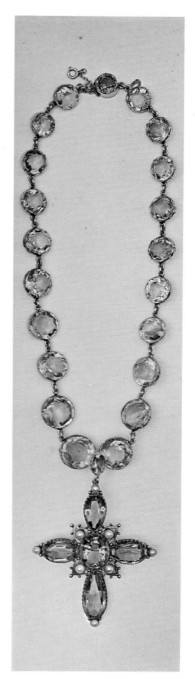

Private Collection

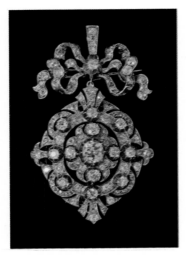

N. Bloom & Son

Plate 45

Brooch/Pendant. Diamonds set in
silver backed with gold for stability.
Adaptable for wearing as a brooch or
as a pendant; the lower section can
also be detached and worn separately
as a pendant.
c. 1880

Conventional diamond jewel-
lery which was intended for
wear at Court and on formal
occasions was more traditional
and to all intents and purposes
little affected by changing
fashions and new ideas.

This brooch/pendant dating
from about 1880 is based on
the 18th-century type, sur-
mounted by a bow or a
crown, which was designed to
enclose or support an order of
some kind, such as the Golden
Fleece, or to provide a glitter-
ing frame for a portrait
miniature. Its precision and
rigidity however, leave one in
no doubt that this piece was
made in the second half of the
19th century.

Plate 46

Necklace and brooch part of a parure.
Brilliant and rose-cut Bohemian
garnets mounted in silver.
BOHEMIAN (?): *c.* 1880

The stone which appeared
consistently in the Victorian
period, irrespective of the
category of jewellery, was the
garnet set *en cabochon*, that is
with an unfaceted, rounded
and highly polished surface – a
method of handling the stones
which dates back to the
Romans. Garnets treated in
this way were also known as
Carbuncles and were usually
backed with foil for added
brilliance and intensity of
colour. However in the 1880s
garnet jewellery was given a
completely different look
when clusters of small brilliant
or rose-cut stones were *pavé*-set
in almost invisible silver
settings. The flower-shaped
units and drops of this necklace
are typical and featured also in
earrings and rings, while a
popular form for brooches and
pendants was the densely built-
up cluster type also illustrated.

Courtesy of Mrs. Collins, Texas

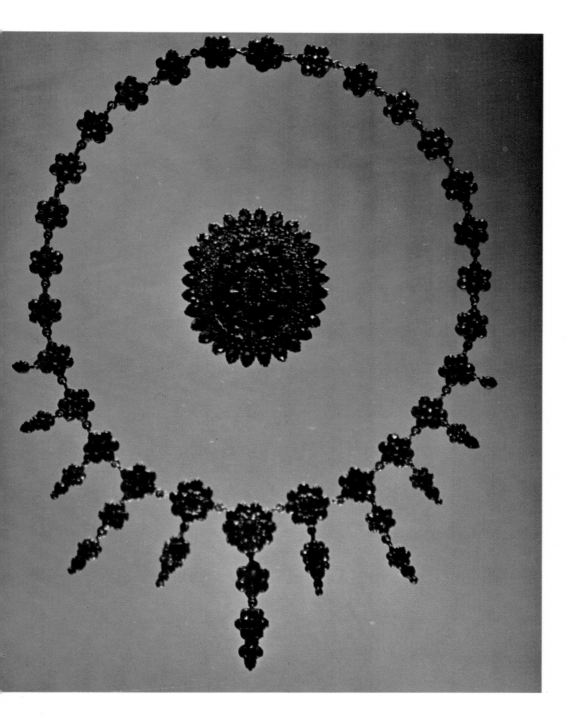

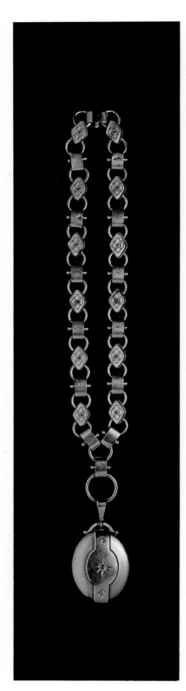

Plate 47

Locket and chain. Gold; the locket is set with three diamonds, the central one in a 'gipsy' setting. The lozenge-shaped units of the chain are decorated with fine rope-work and granulation.
ENGLISH: 1885–1890

The image of womanhood in the eighties, as dictated by certain fashions of the decade, was a formal and uncompromising one: high-necked dresses with cuirass bodices, tightly corsetted waists and bustles; the suitable adornment for this being a substantial and equally uncompromising gold chain with locket attached, as illustrated. It was against this kind of image that the 'aesthetic' people were reacting by wearing long loose-fitting dresses, simple beads and oriental jewellery (see Plates 42 and 43).

Lockets, enclosing a lock of hair or portrait of a loved one, were an important adjunct to the Sentimental jewellery of the Victorian period (see Plates 22 and 23) and as such were never entirely absent from the scene. For a short time in the middle of the century when lockets were less fashionable, compartments were placed on the reverse of pendants and brooches to hold the precious relic, but from the seventies onwards they reached new heights of popularity. With improved methods of mass-production, each type could be reproduced almost *ad infinitum*, using steel dies which stamped out both sides of the locket, including hinge and fastening, in one operation. In gold or silver, and gilded and silvered base metals, some had plain unworked surfaces with a diamond or pearl in the 'gipsy' setting or bore a monogram perhaps enriched with enamel; some were engraved all over with a floral pattern or engraved or embossed with motifs borrowed from the neo-Etruscan, Japanese or Celtic styles. They might be set with turquoises, moonstones or amethysts or with a group of coloured stones whose initial letters spelt out the words REGARD or DEAREST. Novel shapes such as books, hearts, padlocks and purses abounded, the smaller ones being attached to bar brooches or bangles. They were also made in carved jet with a matching chain, and in bog oak and tortoise-shell.

Anne Bloom

Plate 48

Brooch. Diamonds and garnets set in silver backed with gold for stability; in the form of three birds perched on a gold bugle.
Probably FRENCH: 1889–1890. A similar brooch was made by René Lalique *c.* 1889, (see Vever Vol. III page 698).

Brooch. Diamonds and garnets set in silver backed with gold; in the form of a swallow in flight.
FRENCH or ENGLISH: 1880–1890

Brooch. Diamonds set in silver with garnets, coloured gold and pearls; in the form of a frog climbing a gold trellis, with a branch of oak leaves and acorns in two colours of bloomed (see Plate 18) gold.
FRENCH or ENGLISH: 1890s

Two Brooches. Diamonds and garnets set in silver backed with gold; in the form of a fox head and brush, and a running hound.
FRENCH OR ENGLISH: 1890s

The jewellery of the nineties was small, delicate and largely uncoloured. Diamonds, pearls, opals and moonstones were used for the multitude of tiny brooches and pins which nestled in the folds of lace, on the scarves and bonnet strings of the very feminine clothes and in the upswept hair. For these, sporting motifs, and particularly those of horse-racing and the hunt which had been popular since the 1860s, combined with sailing ships, swallows, owls, frogs, insects and lizards. Narrow gold bar brooches, bangles and rings were decorated with a solitary motif taken from the wide range of popular novelties which had been accumulating during the last quarter of the century with the massive build-up of mass-produced jewellery which emanated from the centres in Birmingham: crescents, stars, shamrocks, hearts and wishbones can be added to those already mentioned. There was more sporting jewellery celebrating tennis and golf with rackets, clubs and balls in gold and pearls, and plaque brooches featuring girls' names, monograms, and such mottoes as 'Merry Thought' and 'Mizpah'; the list is endless.

N. Bloom & Son

Plate 49

Sautoir or neckchain. Fine gold chain with pendent cabochon garnets, suspended from diamond-set silver mounts in the form of leaves which are backed with gold. The length of the chain is adjustable.
Mark: 🌸 One of the marks of Child and Child of London.
c/c
ENGLISH: 1890s

In the winter of 1890, almost a century after the fashion had first appeared in post-revolutionary France, the long gold chain or *sautoir* was reported in England to be the latest novelty in jewellery. In the interim, the only significant change which had taken place was in the manner in which it was worn. Late Victorian *sautoirs* were worn around the neck and fell well below the waist, where formerly they had been slung over one shoulder to fall diagonally across the body from shoulder to hip. The *sautoirs* of the nineties could either be tucked into the waist or, like the long watch chains of the twenties and thirties, be caught up with a brooch on the bodice. Links of the chains were separated at intervals by diamonds, pearls, or hardstone beads and some were finished with jewelled slides, tassels or drops. They were also made of pearls and were sometimes worn with the fashionable dog-collar.

The fine gold chain of this *sautoir*, which terminates in jewelled cabochon garnet drops, is linked by the largest stone which conceals a device for adjusting its length.

Cameo Corner

66

Plate 50

Flexible aigrette or brooch. Diamonds
mounted in silver backed with gold;
in the form of a feather.
Marks: M N, divided by a floral device;
unidentified.
Probably ENGLISH: 1890s

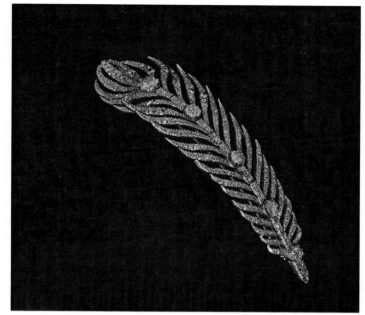

N. Bloom & Son

Aigrettes – hair ornaments composed of feathers or of jewelled
feathers worn with real ones – were fashionable in the 1860s when
amazing ornaments of long swirling feathers were made by the
French *joailliers*. A lighter version appeared in the 1890s to wear
on the softly piled up hair of the *fin de siècle*. Dating from this
time, the flexible diamond-set feather illustrated is divided into a
number of small sections to make it fully articulated. Its stiffness
of design and execution suggest English manufacture.

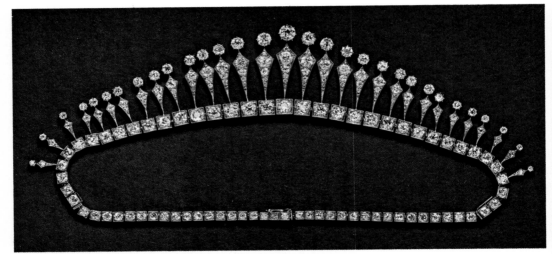

Plate 51

Necklace or tiara. Diamonds set in
silver backed with gold for stability.
To form the tiara, the front section is
removed by releasing the clasps on
either side. Necklace/tiaras adaptable
in this way are typical of the late
1880s and 1890s. (see Bibliography:
Flower *fig.* 79a).
c. 1895

The great changes in taste which characterize the last quarter of
the century affected even the cautious designer of formal gem-set
jewellery bringing a new lightness and abstraction to his work.
Diamonds were in plentiful supply from the recently discovered
mines in South Africa and by the nineties had reached a peak of
popularity, while coloured stones and colourful settings were
now quite out of favour. The *joaillier* (the jeweller who worked in
precious stones) had displaced the *bijoutier* (the jeweller who
worked in metals and enamel) in importance, and his aim was to
create a practically invisible setting so that full attention could be
focused on the quality of the stones themselves. Diamond tiaras,
rivières, and bracelets were essential adornment for the fashionable
lady in society and it was considered that the only stones which
could legitimately be combined with them were the nearly
colourless opals, moonstones and pearls.

In the more modest range of 'popular' jewellery, the new
fragility manifested itself in gold bracelets of the thinness of wire,
delicate pendants of small pale stones suspended in twists of gold
wire, and narrow rings.

Plate 52

Necklace. Enamelled gold set with
diamonds and pearls.
Marks: C & A G, one of the marks of
the Giuliano firm.
ENGLISH: *c.* 1900

This graceful openwork neck-
lace, with its outline of everted
scrolls and festoon pendant,
dates from the turn of the
century and shows the influ-
ence of the prevailing Art
Nouveau movement. It is
signed C & A G, and as Giuliano
himself died in the middle of
the decade it must be the work
of his sons Carlo and Arthur
who continued to produce
work commensurate with his
high standards.

The necklace is decorated
with the adroit use of 17th-
century-type black and white
enamelling which was so
characteristic of Giuliano's
work. Each scroll and con-
necting unit is stroked with
white enamel and given
emphasis by the addition of
minute flicks of black, while
the inner edges are of black
touched with white in a
reverse procedure as also seen
on Giuliano's Indian necklace
(Plate 41). A similar necklace is
in the Victoria and Albert
Museum (M31-1970).

S. J. Phillips

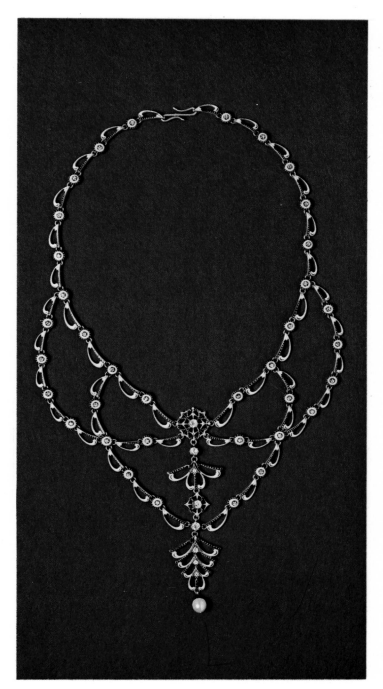

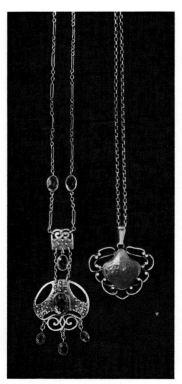

Jeri Scott; Chelsea Antique Market

Plate 53

Left to right
Pendant. Silver with gold-mounted amethysts

Marks: ⓋB°ᵒ : the monogram of Murrle Bennett & Co., of 13 Charterhouse Street, London E.C.1
GERMAN: *c.* 1902

Pendant. Silver set with enamel
ENGLISH: *c.* 1902

To the purist leaders of the Arts & Crafts Movement (see Introduction), the Continental Art Nouveau was an effete style composed of weak undulating forms; its objectives were gratuitously decorative and its ends no less commercial than anything which had preceded it in the second half of the 19th century. Many goldsmiths in the Movement, including Henry Wilson, Alexander Fisher, and most of all C. R. Ashbee with his Guild of Handicraft, were as much concerned with theories as with practice. They wished to dissociate themselves completely from commercial production and to run their workshops according to the ideals and methods of medieval craftsmen. With many of the principal contributors to new jewellery design thus ignoring the Continental movement and producing their own highly idiosyncratic work, its interpretation and dissemination in England tended to fall to the commercial jewellers.

As will be seen, Liberty & Co were quick to realize the potential of avant garde design, and other firms soon followed suit. Mass-produced versions – some of them very weak – of French, Belgian and German Art Nouveau became their stock-in-trade, along with pieces derived from Liberty's craftsmen, and Ashbee and other members of the Arts & Crafts Movement, whose influence can be seen in the pendant *(right)*. The nacreous appearance of the enamel with which this pendant is set, is obtained by laying the vitreous substance over foils; a technique which was revived in France and England from the last quarter of the 19th century.

There is evidence to suppose that some firms imported Continental pieces which they then sold as original English products. A case in point is the silver and amethyst pendant *(left)* which appears to have taken *Jugendstil* – the German equivalent of Art Nouveau – as its model, but is in fact of foreign manufacture. It bears a German silver warranty mark, indicating its actual origin, to which has been added the monogram of the English firm Murrle Bennett & Co.

In editions of *The Studio* during 1902–1903, pendants and brooches of a similar character are featured in advertisements which claim that: 'These designs are the property of and made up by Murrle Bennett & Co., 13 Charterhouse Street London E.C'.

Plate 54

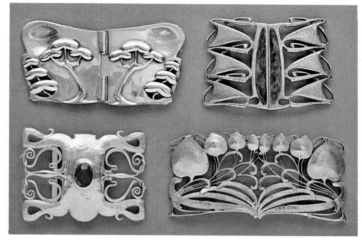

The Purple Shop

Stile Liberty was the Italian term for Art Nouveau – a measure of
the degree to which Liberty & Co. was considered in some
quarters to be the exemplar of the Art Nouveau movement.

Arthur Lasenby Liberty's firm had been importing Orientalia
(see Plate 42) since the mid-seventies; some of the imported work
being mounted in England and stamped with Liberty's mark. In
1899 the 'Cymric' scheme, the brain-child of Arthur Lasenby
Liberty and his fellow director H. Llewellyn, went into
production. It consisted of a range of silver and jewellery which
was to be produced in London and also by the firm of W. H.
Haseler in Birmingham. A new company, of which Haseler were
shareholders, was created for the purpose, and a new mark – L &
Co – was registered in London and Birmingham. The name
'Cymric' was intended to allude to the Celtic inspiration which
was the acknowledged source of the designs, though in fact the
various influences of the Arts & Crafts Movement, of Continental
Art Nouveau, Japonisme and the work of the Belgian architect
and designer Henri Van de Velde (1863–1957) can all be detected
both in the design and manufacture of the range. The buckle, top
left, is clearly based on Japanese forms, while that on the lower
left, with its spreading tendrils and fire opal suggests a debt to
C. R. Ashbee (1863–1942) the founder, in 1888, of the School and
Guild of Handicraft.

The jewellery was made in part by machine, in part by hand,
and the craftsmen and designers were required to remain
anonymous. However, the work of Bernard Cuzner, Oliver
Baker, Reginald Silver, and others can be recognized amongst the
illustrations of jewellery in the 'Cymric' catalogues and Arthur
Gaskin who was responsible for the necklace (Plate 57) is known
to have contributed designs around 1900. Haseler also marked
some Liberty-designed pieces with their own mark, W. H. H.
Production, which was prolific well into the 1920s.

71

Plate 55

Above
Buckle. Silver
Marks: Savard: the mark of Maison Savard of Paris.
FRENCH (Paris): before 1900

Below
Buckle. Silver-gilt set with unbacked agates.
Marks: VEVER PARIS: the mark of Maison Vever of Paris.
N L in a horizontal lozenge, the initials separated by a star-shaped device. (Unidentified). Paris silver restricted warranty mark for 1883.
FRENCH (Paris): *c.* 1901

The high point of Art Nouveau was reached around 1900 and was manifested in the spectacular displays at the Paris Centennial Exhibition of the same year. Artists, architects, and designers, as well as trained jewellers, stimulated by the creative atmosphere of the *fin de siècle* were suddenly finding in jewellery the scope for experimenting with the free forms of the new style (see Introduction).

In terms of output, the house of Vever was – after René Lalique – the single most productive firm at that time, and employed several notable designers and jewellers. A well-established family firm which had won a *Grand Prix* for jewellery at the Universal Exhibition in 1889, it was run jointly by the brothers Paul (1851–1915) and Henri Vever (1854–1942) who was the author of *La Bijouterie Française au XIX^e Siècle* which was published in 1908, and is the standard work on French 19th-century jewellery (see Bibliography).

The silver-gilt buckle (opposite) is marked VEVER PARIS and N L. An identical buckle is shown in Volume III (p. 751) of Henri Vever's book at the work of Georges Le Turque. In the text Vever records that Le Turque (*b.* 1859) had been a pupil at *L'Ecole des Arts Décoratifs* and had subsequently worked with the medallist Duval before starting on his own in 1894. As Volume III also illustrates further examples of the work of *Maison Le Turque* (see pp. 646-7) it would seem that Le Turque had his own business and was not therefore employed by the house of Vever. A possible explanation for the anomaly posed by the conflicting marks on the buckle shown here is that Le Turque was a manufacturing goldsmith, supplying to the trade, whose original article was produced in a series by the house of Vever. The buckles were then marked with the house signature plus that of the particular craftsman who carried out the work.

Another example of multiple production is seen in the silver buckle (opposite above). The buckle, which is also illustrated in Volume III of Vever (p. 607), is entitled *Jeune Fille aux Iris* and relates closely to a silver pendant which was included in the 'Slave to Siren' exhibition in 1971 (see Bibliography). Curvilinear compositions of this kind, which combined female heads with plant forms whose stems curl back on themselves in the requisite Art Nouveau 'whiplash' curve, were prevalent from before 1900.

The Purple Shop

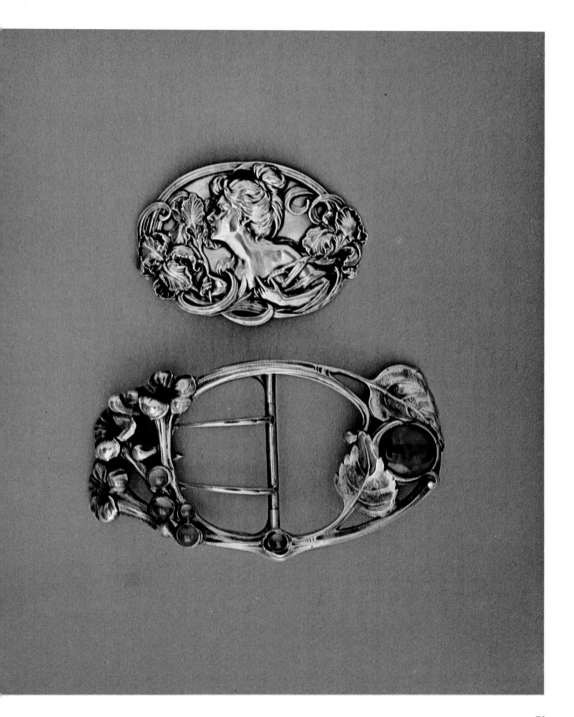

Plate 56

Above
Brooch. Silver with *Plique à Jour* enamel and set with a stained chalcedony in imitation of Chrysoprase.

Marks: 🔲 : one of the

monograms of Otto Prutscher of Vienna.
Deposé 900: a German silver warranty mark.
AUSTRIAN: *c.* 1900—1902

Centre left
Brooch. Silver with *Plique à Jour* enamel; in the form of a mermaid.

Marks: (TF) Theodor Fahrner

Deposé 935: a German silver warranty mark.
GERMAN: *c.* 1902—1903

Centre right
Brooch. Silver with *Plique à Jour* enamel and set with a garnet and stained chalcedony in imitation of Chrysoprase; in the form of a peacock.
Marks: M (?) in a lozenge and others which are indecipherable.
900: a German silver warranty mark.
GERMAN: *c.* 1900—1902

Below
Belt 'flirt' or slide. Silver set with amethysts.
Marks: OMAR RAMSDEN ET ALWYN CARR ME FECERUNT: one of the marks of the English silversmiths Omar Ramsden and Alwyn Carr who were in partnership between 1898 and 1919 in London, where they ran a workshop on Arts and Crafts lines.
ENGLISH: *c.* 1902

An outstanding characteristic of Art Nouveau and a factor which is often cited as the principal reason for its ultimate unwearability, was the tendency to make translucent materials crucial to the composition. Unfortunately, as witnessed here in Austrian, German, and English work of the early 1900s, the effect of these materials can only be realized fully when light is passed through them. In one, two, and three colour and contrast are achieved by the use of *plique à jour*, the early enamelling technique which was revived at this time and was a favoured medium of the Art Nouveau jeweller. Certain unbacked stones, such as the amethysts seen here in the Decadence belt 'flirt' which is one of the few pieces of jewellery made by the English silversmiths Omar Ramsden (1873—1939) and Alwyn Carr (1872—1940) — and the very popular chrysoprase, were employed in a similar way. The staining of chalcedony in imitation of this latter stone had been a frequent practice from the early-19th century. It was done by immersing the porous chalcedony in a solution of chromium or nickel salts. The resultant chrysoprase-green can be seen in the central stone of the top brooch and in the 'eyes' of the peacock feathers. The brooch (*top*) by the Viennese Otto Prutscher (1880—1949) though conceived in the abstract and angular manner of the *Jugendstil* is, in this case, softened and romanticized by the addition of stylized trees; a motif which was also occurring in England in the first decade of the 20th century — see the Liberty buckle (*top left*) on Plate 54, and *The Studio Special Winter Number 1902: Modern Design in Jewellery and Fans* (British Section). It was later to come up again in the Art-Deco of the 1920s and 30s.

The highly decorative and colourful peacock (*right*), a survivor from the 1860s (see Plate 39) was an obvious subject for the designers of this period and the bird or its plumage figure prominently in the *genre*, especially in England and France.

A particular treatment of mermaid figures, in which the arms linked with the tail forming a circular or ovoid composition, appears to have been generally popular in Germany around the turn of the century. The mermaid brooch (*left*) by Theodor Fahrner is similar to brooches by Theodor von Gosen (*b.* 1873) which are illustrated in the German section of *The Studio* number mentioned above, and to a cravat pin, probably also by Fahrner, which was shown in the *Kunsthandwerk um 1900* exhibition held in Darmstadt in 1965 (see Bibliography).

The Purple Shop

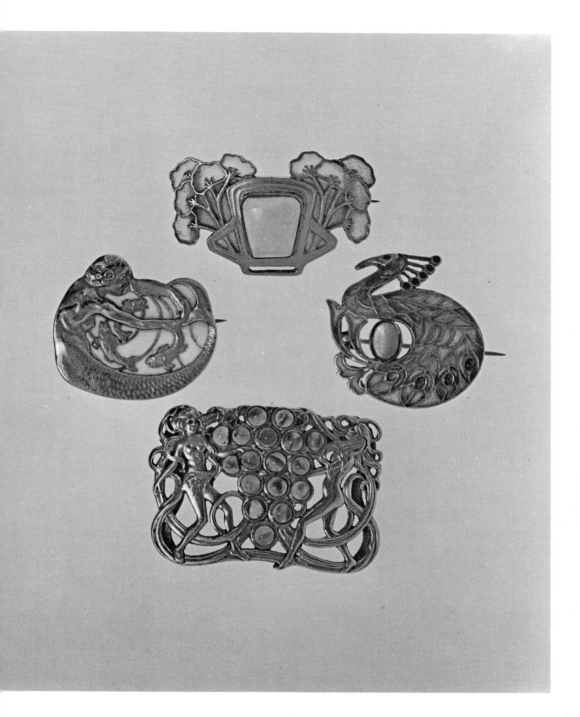

Plate 57

Necklace and Pendant. Enamelled
silver set with pearls.
Marks: G, the mark of Arthur and
Georgina Gaskin.
ENGLISH (Birmingham): *c.* 1905

The Arts & Crafts Movement in England produced a number of designer-craftsmen whose work was to be the stylistic source for much of the commercial jewellery design of the first quarter of the 20th century. Particularly influential in this respect was the work of Arthur and Georgina Gaskin. Arthur Gaskin (1862–1928), formerly a painter and illustrator, was in sympathy with the ideas of William Morris (1834–1896) with whom he collaborated on Edmund Spenser's *Shephearde's Calendar* for the Kelmscott Press.

Both he and Georgina Cave France (1868–1934) whom he married in 1894, had studied at the Birmingham School of Art. In the late-nineties they began making jewellery, with the emphasis on design and hand-craftsmanship; living in the centre of mass-production in Birmingham they were singularly aware of the worst aspects of machine-made jewellery and of the necessity for providing an alternative to it.

After an early period of bold and simple designs the Gaskin jewellery evolved into a fairly rigid but intricate formula based on floral themes, which altered little over a period of more than twenty years – apart from the post-1910 addition of silver birds to the repertoire – as can be seen by examining the Gaskin book of drawings for jewellery dating from about 1902–1923 in the Victoria and Albert Museum Print Room (E672-709-1969). The silver openwork units which were fundamental to the designs were often arranged in a manner which recalls Baroque jewellery. They were set with semi-precious stones, or pearls, opals, or moonstones, and additionally, in most instances, were decorated with translucent enamels in a narrow range of blues and greens.

Victoria and Albert Museum
(Circ. 359-1958)

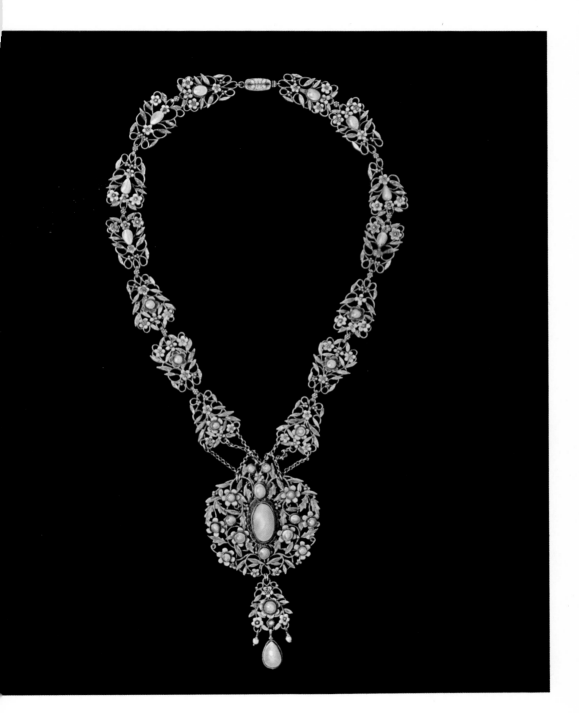

GLOSSARY

BRILLIANT CUT: a method of cutting stones in which the upper part or crown has 33 facets and the lower part, the pavilion or culasse, has 25; the division between the two parts being the point of greatest circumference which is called the girdle.

CAMEO: a gem, hardstone or shell, usually having two or more layers of contrasting colours, of which the upper section is carved in relief while the lower serves as a ground.

CANETILLE: the distinctive type of filigree which was popular in France for jewellery settings during the first half of the 19th century. It is based on individual shell and burr-like motifs of coiled wire which are sometimes combined with leaves and flowers. With the addition of metal grains to the scheme it is known as *graineti*.

CARTOUCHE: a type of ornament based on a tablet or scroll. It can be used decoratively and for inscriptions.

CHASING: the process of decorating metals from the front where the surface is modelled by means of punches and a hammer without actually removing any of the metal; in which respect it is the opposite of *engraving*.

ELECTROTYPE: an object which has been formed in a tank by means of electrical deposition of metal into a mould; a process which was developed in the 1830s and is used both for reproducing existing objects and for creating original ones. Also known as *Galvanoplastik* and later, in the U.S.A., as Electroforming.

EMBOSSING: generally has the same meaning as *Repoussé*; the word being derived from 'boss', or raised shape.

ÉMAIL EN RÉSILLE SUR VERRE: an enamelling technique which was practised for a short time in the first half of the 17th century, in which plaques of glass are engraved with a design and the channels thus formed are filled with thin strips of enamelled gold foil.

ENCRUSTED ENAMELLING: a type of painted enamelling, it is used to decorate surfaces which have already been modelled. Vitrifiable colours are applied with a brush or palette knife and by firing are fused with a ground of white enamel.

ENGRAVING: the process of decorating or texturing metals from the front by incising the surface with gravers, burins, or scorpers.

GIPSY SETTING: sometimes known as the star setting: in which one large stone or a number of small ones, in the form of a star, are recessed into the surrounding metal – or a larger stone of contrasting colour. The metal or stone mount is incised with lines which seem to radiate from the star.

GIRANDOLE: a type of earring or brooch which has three or more drops suspended from a larger stone or section of openwork; the drops being placed in such a way as to form a 'V' shape. Originally a Baroque form.

GRANULATION: a form of low relief decoration which is achieved by the application of minute grains of gold to surfaces of the same metal; a decorative technique which is known to have been employed by Minoan and Etruscan goldworkers and was revived by Castellani in the 19th century.

NÉCESSAIRE: a small portable lidded box, often elaborately ornamented, containing toilet requisites, etc.

PARURE: a suite of matching jewellery. Also DEMI-PARURE, where there are only two matching items, e.g. necklace and earrings.

PAVÉ-SET: sometimes called the paved setting: in which a number of small stones are arranged as closely together as possible and recessed into their mount, the only visible metal being the grains which hold each stone in place.

PLIQUE À JOUR: a type of translucent enamel which has no metal backing and is supported by a framework of wire cells or openwork. The effect is similar to stained glass.

REPOUSSÉ: (French: *pousser*, to push): a method of decorating metals where parts of the design are raised in relief from the back or the inside of the article by means of hammers and punches. Definition and detail can then be added from the front by *chasing* or *engraving*.

RIVIÈRE: a necklace consisting of one or two rows of large, evenly matched or graduated stones, usually diamonds.

ROCAILLE: a type of rococo ornament based on sea shells, rocks and crustacea.

ROSE-CUT: a method of cutting stones in which the base is flat and the upper part has a number of triangular facets.

SÉVIGNE: a bow-shaped bodice ornament of gold or silver which is lavishly set with stones and worn just below the corsage. The basic form is often elaborated with openwork floral motifs and is sometimes combined with the *Girandole*.

SELECT BIBLIOGRAPHY

BRADFORD, Ernle, *English Victorian Jewellery*, Country Life, 1959
BURY, Shirley, *The Liberty Metalwork Venture*, Architectural Review, CXXXIII, 1963. *Pugin's Marriage Jewellery*, Victoria & Albert Museum Yearbook, 1969. *Alessandro Castellani and the Revival of Granulation*, The Burlington Magazine, October 1975. *Rossetti and his Jewellery*, The Burlington Magazine, February 1976. *Jewellery 1795–1905* (To be published).
CASTELLANI, A, *Antique Jewellery and Its Revival*, London, 1862
CLARK, Kenneth, *The Gothic Revival*, Constable, 1950 (2nd ed.)
CLIFFORD, Anne, *Cut Steel and Berlin Iron Jewellery*, Adams & Dart, 1971
COOPER, Diana & BATTERSHILL, Norman, *Victorian Sentimental Jewellery*, David & Charles, 1972
DUMONT, F, *Froment-Meurice, le Victor Hugo de l'Orfèvrerie*, Connaissance des Arts, No. 57, 1956
EVANS, Joan, *A History of Jewellery, 1100–1870*, Faber, 1953 (new ed. 1971)
FALKINER, Richard, *Investing in Antique Jewellery*, Barrie & Rockliff, The Cresset Press, 1968
FLOWER, Margaret, *Victorian Jewellery*, Cassel, 1957 (new ed. 1967)
FONTENAY, Eugène, *Les Bijoux Anciens et Modernes*, Paris, 1857
FRÉGNAC, Claude, *Jewellery: from the Renaissance to Art Nouveau*, Weidenfeld and Nicolson, 1965
GERE, Charlotte, *Victorian Jewellery Design*, William Kimber, 1972. *European and American Jewellery 1830–1914*, Heinemann, London, 1975
HUGHES, Graham, *The Art of Jewellery*, Studio Vista, 1972. *Modern Jewellery: an International Survey, 1890–1963*, Studio Vista, 1963
LANLLIER, Jean & PINI, Marie-Anne, *Cinq Siècles de Joaillerie en Occident*, Office du Livre, Fribourg 1971
MUNN, Geoffrey, *The Giuliano Family*, Connoisseur, November 1975. *Giacinto Melillo – A Pupil of Castellani*, Connoisseur, September 1977. *Jewels under the Second Empire*, Connoisseur, December 1978. *Carlo Doria – A Victorian Enigma*, Connoisseur, September 1979. *Jewels by Castellani – Some sources and techniques examined*, Connoisseur, February 1981
NATIONAL MUSEUM OF ANTIQUITIES, Edinburgh, *Brooches in Scotland* (Booklet), 1958
NAYLOR, Gillian, *The Arts and Crafts Movement*, Studio Vista, 1971
d'OTRANGE, M. L., *The Exquisite Art of Carlo Giuliano*, Apollo, June 1954
PETER, Mary, *Collecting Victorian Jewellery*, Macgibbon and Kee, 1970
SCARISBRICK, Diana, *Jewelled Tribute to the Past – The Hull-Grundy Gift at the British Museum*, Country Life, January 29th, 1981
STANTON, Phoebe, *Pugin*, Thames and Hudson, 1971
STEINGRÄBER, Erich, *Antique Jewellery, Its History in Europe from 800 to 1900*, Thames and Hudson, 1957
TAIT, Hugh & GERE, Charlotte, *The Jewellers' Art – An Introduction to the Hull-Grundy Gift to the British Museum*, London, 1978
VEVER, Henri, *La Bijouterie Française au XIXe Siècle*, 1908
WALTERS ART GALLERY, *Jewellery Ancient to Modern*, Baltimore, U.S.A. 1979
WIGLEY, Thomas B, *The Art of the Goldsmith and Jeweller*, Charles Griffin & Co Ltd, 1898
WILSON, Henry, *Silverwork and Jewellery*, John Hogg, 1903

Contemporary Art and Trade Journals
The Art Union, 1839–1848
The Art Journal, 1849–1912
The Art Journal, Catalogues of the International Exhibitions
The Jeweller and Fancy Trades Advertiser, from 1868
The Jewellers', Goldsmiths', Silversmiths' and Watchmakers' Monthly Magazine, from 1862
The Jeweller and Metalworker, from 1894
The Paris Exhibition of 1878, An Illustrated Weekly Review
The Studio, from 1893
The Workshop, 1868–1872

Women's Magazines
La Belle Assemblée
Harper's Bazaar
La Parisienne Elegante
Le Petit Messanger des Modes
The Queen
Women's Domestic Magazine
The World of Fashion
Young Ladies Journal
Salon de la Mode

Exhibition and Sale Catalogues
A LA VIEILLE RUSSIE, New York, *The Art of the Goldsmith and Jeweller*, November 1968
ASHMOLEAN MUSEUM, Oxford, *Finger Rings from Ancient Egypt to the Present Day*, 1978
BIRMINGHAM MUSEUM AND ART GALLERY, *Birmingham Gold and Silver 1773–1973*, July–September 1973
BRITISH MUSEUM, London, *Jewellery through 7000 years*, 1976
CHELTENHAM ART GALLERY AND MUSEUM· *C. R. Ashbee and the Guild of Handicraft*, 17th January–28th February 1981
DUKE UNIVERSITY OF ART, Durham, North Carolina, USA, *From Slave to Siren; The Victorian Woman and her Jewelry from Neoclassic to Art Nouveau*, May 1971
CHRISTIE, MANSON, & WOODS, Geneva, *Castellani & Giuliano*, 15th November 1972; *Luis Masriera-35 Jewels*, 15th May 1980 (Sales)
FINE ART SOCIETY, London, *The Earthly Paradise*, June–July 1969; *The Aesthetic Movement and the Cult of Japan*, October 1972
HESSISCHES LANDESMUSEUM, Darmstadt, *Kunsthandwerk um 1900, Jugendstil, Art Nouveau, Modern Style, Nieuwe Kunst*, Eduard Roether Verlag Darmstadt, 1965
ROYAL ACADEMY OF ARTS, London, *Victorian and Edwardian Decorative Art; The Handley-Read Collection*, March–April 1972
SCHMUCKMUSEUM, Pforzheim, *Goldschmiedekunst des Jugendstils Schmuck und Gerät um 1900*, May–September 1963
VICTORIA & ALBERT MUSEUM, London, *Victorian & Edwardian Decorative Arts*, 1952; *Princely Magnificence*, 15th October 1980–1st February 1981
WORSHIPFUL COMPANY OF GOLDSMITHS, London, *International Exhibition of Modern Jewellery 1890–1961*, October–December 1961; *The Observer Jewellery Exhibition*, The Welsh Arts Council, November 1973; *Omar Ramsden, 1873–1939*, 1973

ask at desk
Central Stacks ADU CIRC -
Victorian jewellery
O'Day, Deirdre.
739.27 022 1982
S

DATE DUE